Zall'

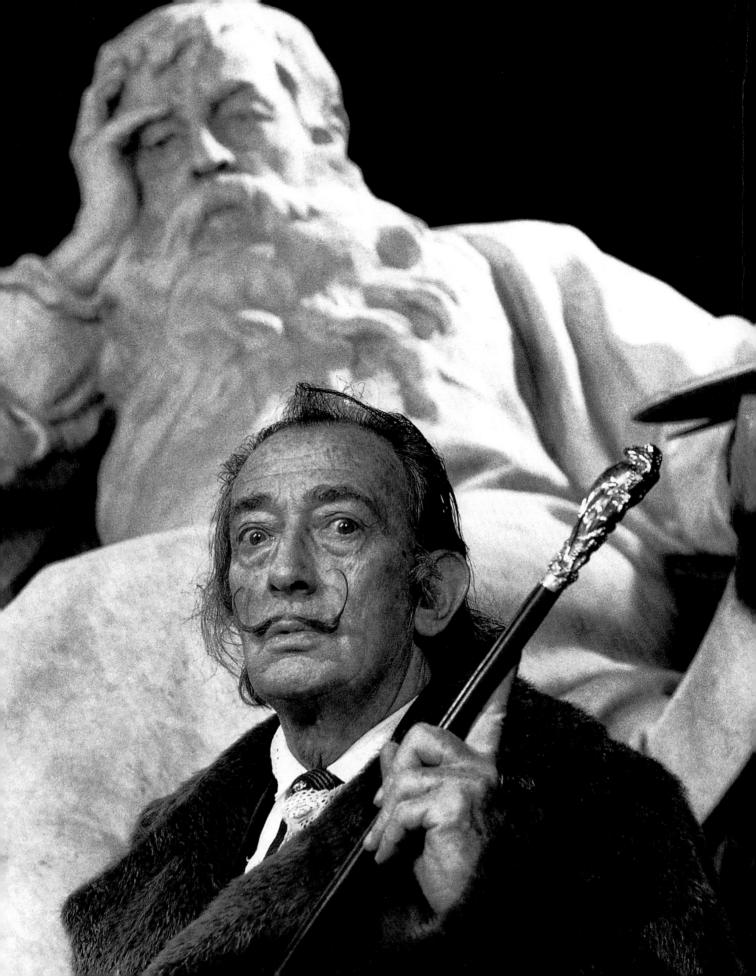

Gilles Néret

Salvador Dalí

1904-1989

Conquest of the Irrational

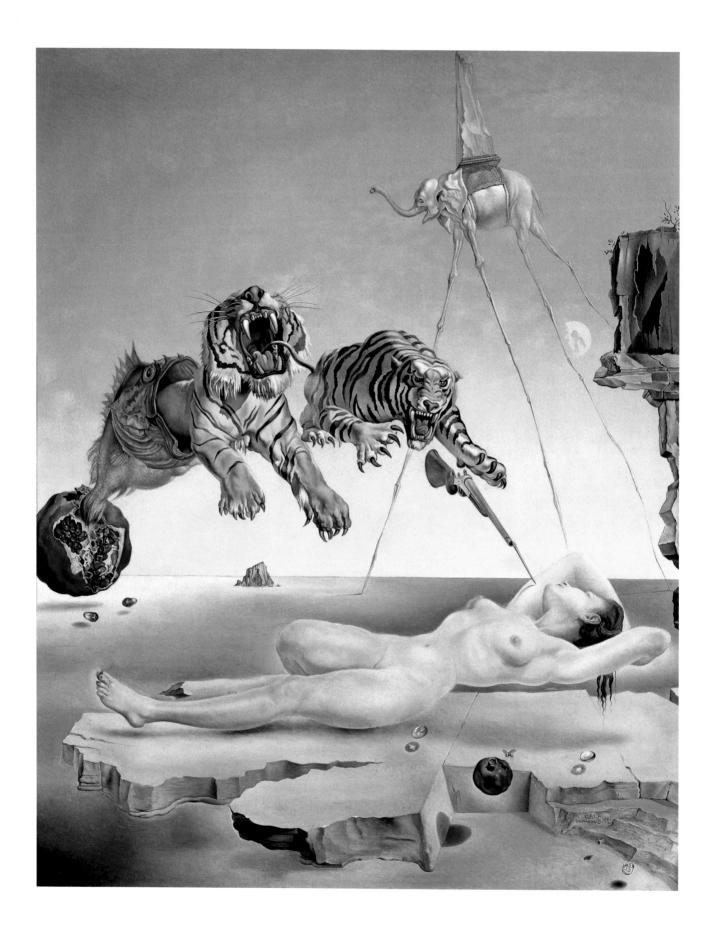

Contents

6 How to Become a Genius

20 The Trial of Love

38 The Triumph of Avida Dollars

54 Hallucinations or Scientific Visions

> 92 Salvador Dalí 1904–1989 Life and Work

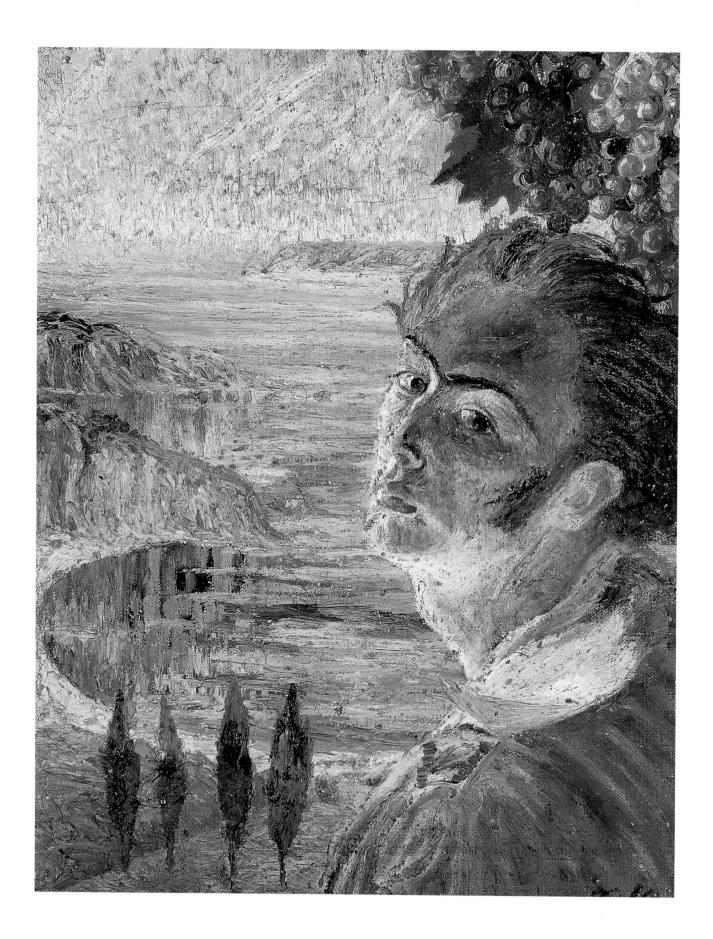

How to Become a Genius

"Every morning when I awake," wrote the painter of the soft watches and burning giraffes, "the greatest of joys is mine: that of being Salvador Dalí . . ." Dalí, a Catalan who was addicted to fame and gold, painted a lot and talked a lot. His favourite topic of conversation was how to become a genius. His recipe: "Oh Salvador, now you know the truth; that if you act the genius, you will be one!"

At the age of six he wanted to become a cook, insisting on using the word in the feminine gender; at the age of seven, Napoleon. "Since then," he later said, "my ambition has steadily grown, and my megalomania with it. Now I want only to be Salvador Dalí, I have no greater wish." During these same early years he painted his first picture. Then, at ten, he discovered the Impressionists, and at fourteen the "pompiers", the academic genre painters of the 19th century. In 1927, at the age of twenty-four, he was already Dalí, and his childhood friend Federico Garcia Lorca dedicated a "didactic ode" to him. Years later he would relate how Lorca, very much smitten, had tried to sodomize him, but did not quite succeed. Ever that Dalínian taste for scandal! His parents had named him Salvador (Span. "el salvador" = the saviour) because – as the artist himself declared – he was destined to be the saviour of painting, which was "in mortal danger from abstract art, academic Surrealism, Dadaism in general, and all anarchic 'isms'".

Had he lived during the age of the Renaissance, his genius might have been more acceptable, even normal. But in our own times, which he himself called "cretinous", Dalí is a permanent provocation. Even though he is now recognized as one of the truly great figures of modern art, ranking alongside Picasso, Matisse and Duchamp, and even though he has managed to seduce the general public and win their favour, his works continue to shock. Many viewers are still tempted to cry "madness", yet Dalí himself insisted: "The only difference between me and a madman is that I am not mad!" It is also true, as he repeatedly said, that: "The only difference between the Surrealists and me is that I am a Surrealist." Just as Monet is the only Impressionist to remain so from start to finish – his fellows would later all branch off towards Cubism, Pointillism or Fauvism – so Dalí remains the most faithful, the only true Surrealist. Even though he also said of himself: "The mills of his mind grind continuously, and he possesses the universal curiosity of Renaissance man."

The Smiling Venus, c. 1921
Temper on cardboard, 51.5 x 50.3 cm
(20¼ x 19¾ in.)
Town Hall of Figueras, on permanent deposit at the Fundació Gala-Salvador Dalí, Figueras

A highly "edible" nude, in the spirit of Catalan culinary atavism, but rendered here in the Pointillist manner.

Self-Portrait, c. 1920 Oil on canvas, 52 x 45 cm (20½ x 17¾ in.) Private collection

"Señor Patillas" (Dalí's nickname was inspired by his striking sideburns) is portrayed against an Impressionist Cadaqués landscape, a motif which reappears time and time again throughout his work. **Portrait of the Cellist Ricard Pichot**, 1920 Oil on canvas, 61.5 x 50 cm (24¼ x 19½ in.) Figueras, Fundació Gala-Salvador Dalí

Using the intimate style of Bonnard to portray his cello-playing neighbour and friend, the youthful Dalí already displays his mastery of a broad range of styles.

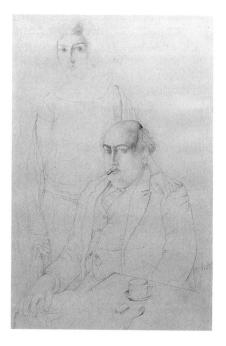

The father's gaze is full of reproach: Salvador, although he may handle his pencil in the manner of Ingres, has just been expelled from the Madrid Academy of Fine Arts.

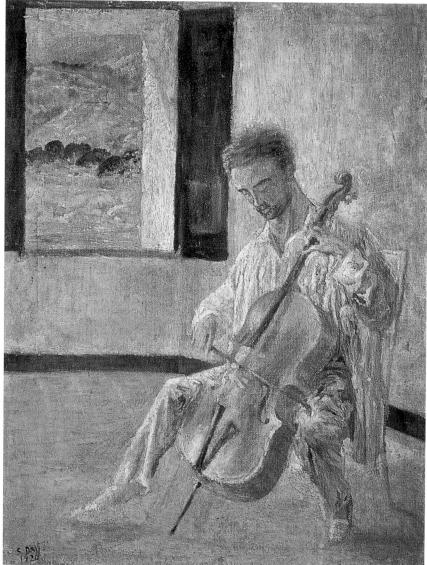

In his foreword to Dalí's Diary of a Genius (Journal d'un genie) Michel Déon writes: "One thinks one knows Dalí because, with extreme courage, he has decided to be a public person. Journalists greedily devour everything he offers them, but finally the most surprising thing about him is his peasant good sense - as in the scene where the young man who wants to know the secret of success finds himself advised to eat caviare and drink champagne, so as not to slave away and die of hunger like a day labourer. But the best thing about Dalí are his roots and his antennae. Roots that reach down deep into the earth, where they search for all those 'succulent' things (to use one of Dali's three most favourite words) which man has been able to produce in forty centuries of painting, architecture and sculpture. Antennae directed to the future, picking up its vibrations, anticipating and comprehending it at lightning speed. It cannot be sufficiently emphasized that Dalí is a man of insatiable curiosity. All his discoveries and inventions are reflected in his work and appear there in scarcely transposed form." In short, Dalí was - as the public well appreciated - entirely representative of his age, if only in turning himself into a "star".

But Dalí was also a Catalan. He saw himself as a Catalan and insisted on this privilege. He was born on 11 May 1904 in Figueras, a small town in the province of Gerona. Later he was to celebrate this event in his own inimitable way: "Let all the bells ring! Let the toiling peasant straighten for a moment the ankylosed curve of his anonymous back, bowed to the soil like the trunk of an olive tree, twisted by the tramontana, and let his cheek, furrowed by deep and earthfilled wrinkles, rest in the hollow of his calloused hand in a noble attitude of momentary and meditative repose, Look! Salvador Dalí has just been born! ... It is on mornings such as this that the Greeks and the Phoenicians must have disembarked in the bays of Rosas and of Ampurias, in order to come and prepare the bed of civilization and the clean, white and theatrical sheets of my birth, settling the whole in the very centre of this plain of Ampurdán, which is the most concrete and the most objective piece of landscape that exists in the world."

Portrait of My Father, 1920 Oil on canvas, 91 x 66.5 cm (35¾ x 26 in.) Figueras, Fundació Gala-Salvador Dalí. Dalí bequest

The distinguished Figueras notary is shown in full majesty against Dalí's favourite landscape.

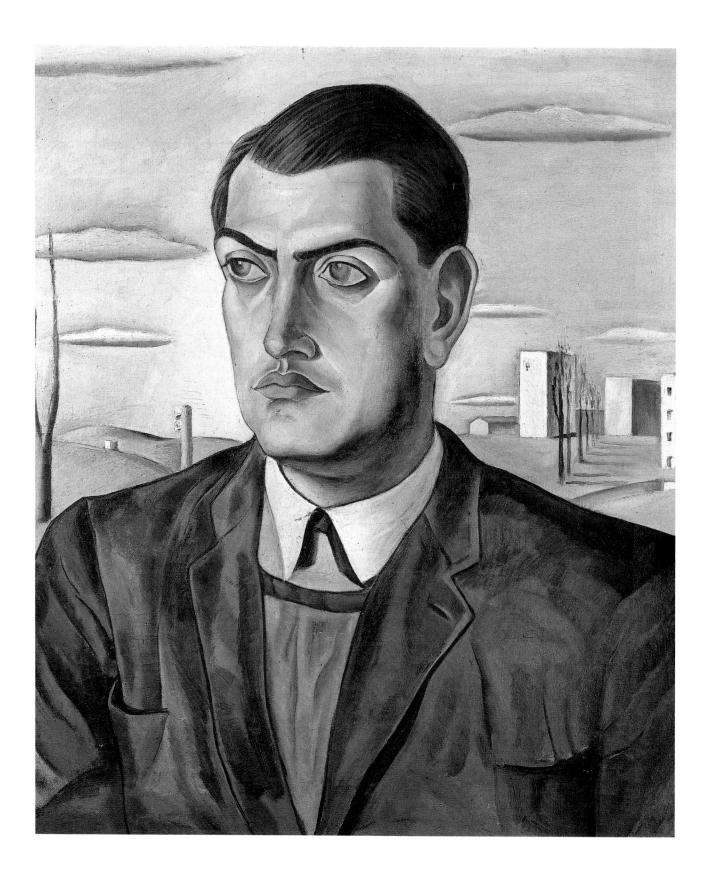

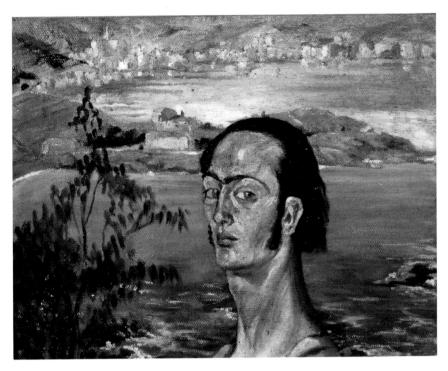

Self-Portrait with Raphaelesque Neck, c. 1921 Oil on canvas, 40.5 x 53 cm (16 x 20¾ in.) Figueras, Fundació Gala-Salvador Dalí. Dalí bequest

This was Dalí's Impressionist period, into which he nevertheless introduced a classical note by citing Raphael. Thirty years later, Dalí in front of the same Portlligat landscape.

Dalí at Portlligat, *c.* 1950 Photograph by Descharnes

The major obsessions which run through Dalí's work from the beginning stem directly from his Catalan roots. The Catalans are said to believe only in the existence of things they can eat, hear, touch, smell or see. Dalí made no secret of this materialist and culinary atavism: "I know what I'm eating; I don't know what I'm doing." The philosopher Francesco Pujols, a compatriot whom Dalí often quoted, compared the expansion of the Catholic church to a pig that is fattened up to be butchered and eaten.

Dalí in turn gave his own Dalínian gloss on St. Augustine: "Christ is like cheese, or, to be more precise, like mountains of cheese." This culinary delirium recurs regularly throughout his work, whether in the famous "soft watches" (*The Persistence of Memory*, 1931, p. 26), which were derived from a dream of runny Camembert and represent a metaphysical image of time devouring itself and everything else, too; in innumerable *Eggs on the Plate (without the Plate)* (1932, p. 27); in *Anthropomorphic Bread* (1932, p. 28), the *Lobster Telephone* (1936, p. 39) and the *Soft Construction with Boiled Beans (Premonition of Civil War)* (1936, p. 47).

Dalí's Catalan atavism displays itself not simply in a passion for food, however, but also in the visceral presence in his pictures of his beloved Ampurdán plain. For Dalí it was the most beautiful landscape in the world and the leitmotif of his early works. His most famous paintings would take their setting from the stretch of Catalonian coast running from Cape Creus to Estartit, with Cadaqués midway, and they would be bathed in its special Mediterranean light. The excrescences which Dalí so loved – fossilized objects, ossifications, anthropomorphisms and other strange cousins of *The Spectre of Sex-Appeal* (c. 1934, p. 32) – take their origins from the coastal rocks that have been sculpted by the elements. They haunt his work in a variety of guises, whether as *The Enigma of Desire* (1929, p. 23) or in the form of harps which are invisible or the object of meditation (p. 32/33).

Portrait of Luis Buñuel, 1924 Oil on canvas, 70 x 60 cm (27½ x 23½ in.) Madrid, Museo Nacional Centro de Arte Reina Sofía From the very beginning there is scarcely a picture, portrait or composition whose background is not invaded by Catalonia's coastal landscape and rocks, whose almost human shapes are echoed in the figures peopling the canvas. It is a theme running through such diverse works as Self-Portrait (c. 1920, p. 6), The Smiling Venus (c. 1921, p. 7), Portrait of My Father (1920, p. 9), Self-Portrait with Raphaelesque Neck (c. 1921, p. 11), Girl with Curls (1926, p. 13), and Venus and Cupids (1925, p. 14). For we should never forget that Dalí's pictorial nightmares corresponded to real facts stored in his memory. Even the grand pianos which he placed on cliffs or among cypresses were not simply a dream but the memory of things and events which had made an impression on him: his neighbours and friends, the Pichots, all of whom were musically gifted, used to organize open-air recitals with Ricardo on cello, Maria singing opera in her fine

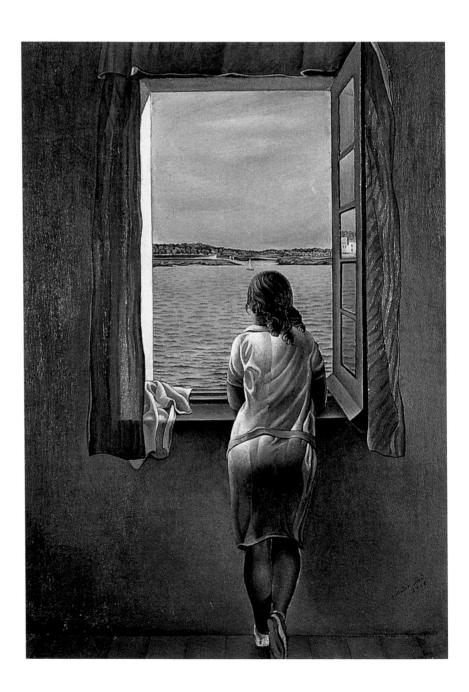

Figure at a Window/Girl at a Window, 1925 Oil on cardboard (masonite), 105 x 74.5 cm (41¼ x 29¼ in.) Madrid, Museo Nacional Centro de Arte Reina Sofía

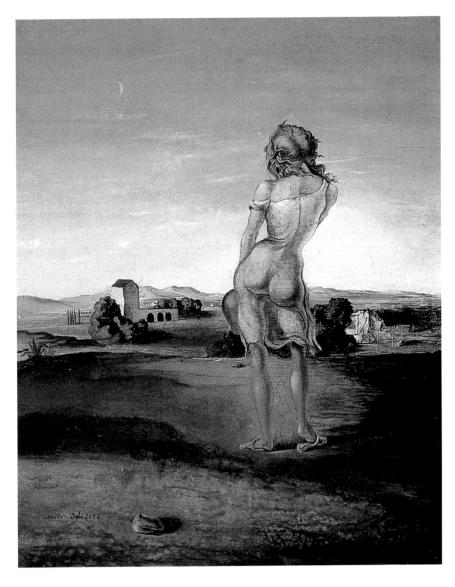

Girl with Curls, 1926 Oil on wood panel, 51 x 40 cm (20 x 15¾ in.) St. Petersburg, Florida, The Salvador Dalí Museum

These rear views emphasizing the female behind are modelled on Ana María or some other Catalan girl, but they also anticipate the back and buttocks of which Dalí dreamed and with which he was later to fall in love – those of Gala, whom he had not yet met.

contralto and Pepito, perched high up on a hill, at the grand piano ... Hence the various evocations of grand pianos in diverse contexts, such as the *Atmospheric Skull Sodomizing a Grand Piano* (1934, p. 30) amongst the rocks.

After passing his school-leaving exams – not without difficulty – Dalí tried to persuade his notary father to let him go to the Madrid Academy of Fine Arts. His son's insistence, the encouragement given by his first teacher Nuñéz and his friends, the Pichots, and perhaps also the death of Dalí's mother in Barcelona in 1921, finally combined to overcome the father's misgivings. The loss of the person who had meant more to him than anyone else in the world caused Salvador Dalí intense grief. Later, he was to write: "I had to achieve fame to avenge myself for the insult which my beloved mother's death represented for me."

But his tutors were a great disappointment to him. They were still exploring the "latest trends" that Dalí had long since left behind him. Enamoured with the modern, they did not teach him the classicism he was seeking. Dalí nevertheless joined Madrid's avant-garde and soon became the head of a circle which included Pepín Bello, García Lorca, Luis Buñuel, Pedro Garfias, Eugenio

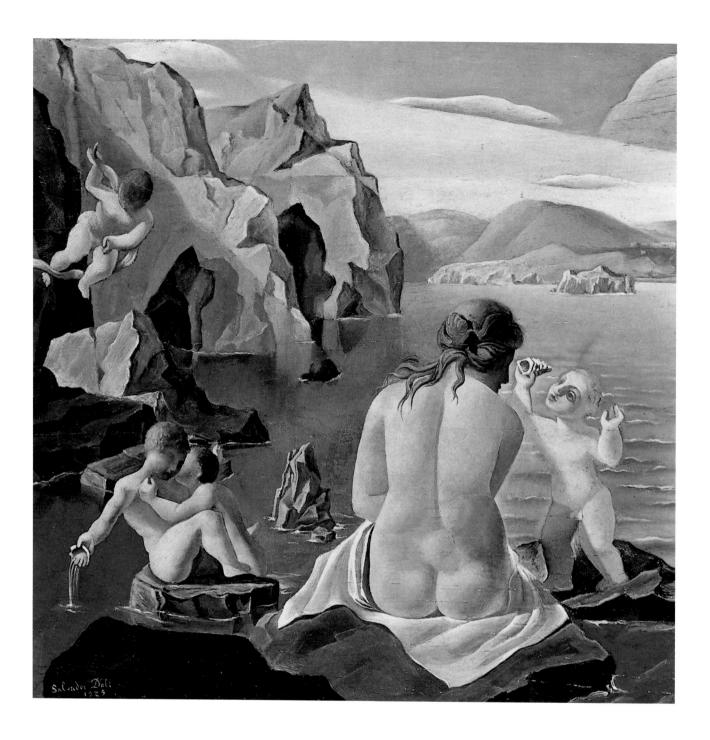

Venus and Cupids, 1925 Oil on wood panel, 20.5 x 21.5 cm (7¾ x 8½ in.) Private collection

Dalí's Cubist, Picasso period ... but the main motif of the picture is still that of the female back and buttocks in the by now familiar landscape. Dalí, his sister and their mutual friend Federico García Lorca used to call this type of subject "pieces of arse".

Montes and Raphael Barradas. It proved to be a blessing in disguise for Dalí that, after two tempestuous years in the company of his friends, he was expelled from the Madrid Academy for inciting the students to demonstrate against the appointment of a mediocre artist as professor. He returned to Cadaqués, where – nicknamed "Señor Patillas" for his striking sideburns (Span. *patillas* = side-whiskers) and recognizable from afar with his brushes tied on a string around his waist – he painted up to five pictures a day. One of these was *Self-Portrait with Raphaelesque Neck* (*c.* 1921, p. 11). In style and title it was intended as a homage to the illustrious predecessor he so admired. His father was reproachful, as revealed by the expression on his face which his son recorded in a

pencil drawing (*Don Salvador and Ana María Dalí*, 1925, p. 8). Dalí's expulsion from the Academy destroyed all the notary's hopes of seeing his son take up an official career. But it was too late; college meant nothing to his son now: Salvador was about to become Dalí!

Dalí had indeed already made child's play of practically all the fashionable modern trends. He had explored Impressionism, Pointillism, Futurism, Cubism, Neo-Cubism and Fauvism, paying homage with astonishing mastery here to Picasso, there to Matisse. He did nothing to hide these influences; they were simply another step towards the images he was pursuing. They held his attention for a few weeks and then he abandoned them, retaining nothing of the experience but a greater confidence, as reflected, for example, in *Portrait of My Father* (1920, p. 9) or *Girl at a Window* (1925, p. 12). In the latter we can already see Dalí's fascination with the female back and buttocks, a preoccupation even more apparent in *Girl with Curls* (1926, p. 13). It can also be rediscovered some thirty years later in *Young Virgin Auto-Sodomized by Her Own Chastity* (1954, p. 79). This picture is the clearest evocation of what, in Dalí's eyes, was his sister Ana María's greatest merit.

Salvador probably did not find it too difficult to convince his father that he should continue his studies in Paris. "Once in Paris", Dalí prophesied, "I shall seize power!" He seems to have spent a week in Paris, probably at the beginning of 1927, chaperoned, as a paternal precaution, by his aunt and his sister. According to Dalí himself he did three important things during his stay: he visited Versailles, the Musée Grevin, and Picasso. "I was introduced to Picasso by Manuel Angeles Ortiz, a Cubist painter from Granada who followed Picasso's work to within a centimetre. Ortiz was a friend of Lorca's and this is how I happended to know him. When I arrived at Picasso's on Rue La Boétie I was as deeply moved and as full of respect as though I were having an audience with the Pope. 'I have come to see you,' I said, 'before visiting the Louvre.' 'You're quite right,' he answered."

It was at this time that Dalí's friend Luis Buñuel approached him with the idea for a film which he planned to make with money provided by his mother, *Un Chien Andalou (An Andalusian Dog)*. In a manner similar to the technique

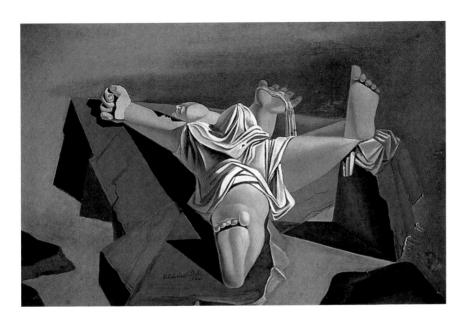

Figure on the Rocks, 1926 Oil on panel, 27 x 41 cm ($10\frac{1}{2}$ x 16 in.) St. Petersburg, Florida, The Salvador Dalí Museum

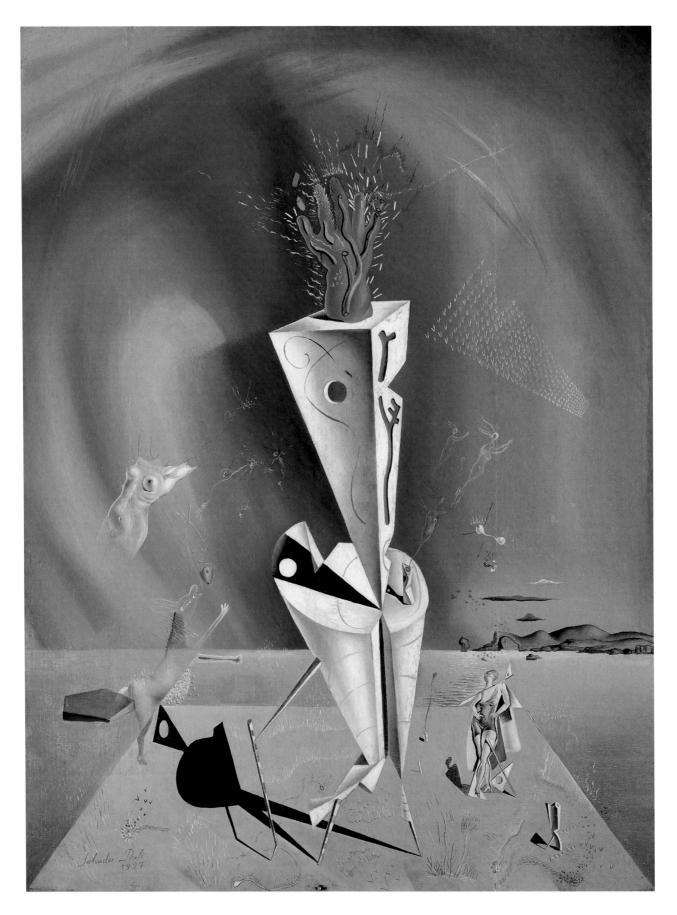

of automatic writing employed by the Surrealists, the two artists created the film by juxtaposing images taken from their own fantasies. Buñuel had seen a ragged cloud passing across the moon and then an eye slashed by a razor. Dalí had dreamed of a hand crawling with ants and a putrefying donkey such as he had recently painted (*The Stinking Ass*, 1928, p. 18). They agreed on just one simple rule – to which Dalí would also remain loyal in the future – as the basis for their work: they would accept no idea or image that was susceptible to rational, psychological or cultural explanation. Open the gates to the irrational! Accept only those images which make a great impact without attempting to discover why.

While waiting to plunge *Un Chien Andalou* "like a dagger right into the heart of witty, elegant and intellectualized Paris" and thus to unlock the doors to the Surrealist group, Dalí was also searching the city for "the woman, elegant or not elegant, to take an interest in my erotic fantasies". In his book *The Secret Life of Salvador Dalí* he writes: "I arrived in Paris saying to myself, quoting the title of a novel I had read in Spain, 'Caesar or Nothing'! I took a taxi and asked the chauffeur: 'Do you know any good whorehouses?' ... I did not visit all of

Apparatus and Hand, 1927 Oil on wood panel, 62.2 x 47.6 cm (24½ x 18¾ in.) St. Petersburg, Florida, The Salvador Dalí Museum

Study for *Honey Is Sweeter than Blood*, 1926 Oil on wood panel, 37.8 x 46.2 cm (15 x 18 in.) Figueras, Fundació Gala-Salvador Dalí

Dalí catalogues some of the key images of this period, which saw him refining his pictorial yocabulary and giving free rein to his fantasies.

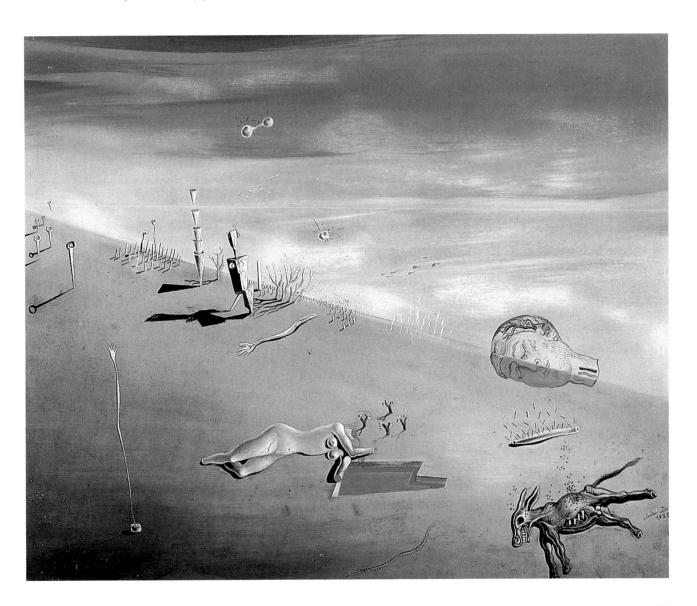

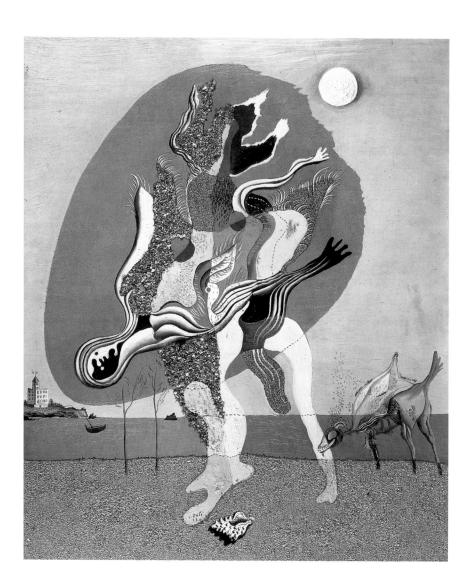

The Stinking Ass, 1928
Oil, sand and shingle on wood,
61 x 50 cm (24 x 19½ in.)
Paris, Musée national d'art moderne,
Centre Pompidou

Prefiguration of a sequence from Dalí and Buñuel's film *Un Chien Andalou*.

them, but I saw many, and certain ones pleased me immeasurably ... Here I must shut my eyes for a moment in order to select for you the three spots which, while they are the most diverse and dissimilar, have produced upon me the deepest impression of mystery. The stairway of the 'Chabanais' is for me the most mysterious and the ugliest 'erotic' spot, the Theatre of Palladio in Vicenza is the most mysterious and divine 'aesthetic' spot, and the entrance to the tombs of the Kings of the Escorial the most mysterious and beautiful mortuary spot that exists in the world. So true it is that for me eroticism must always be ugly, the aesthetic always divine, and death beautiful."

The Lugubrious Game, 1929 Oil and collage on cardboard, 44.4 x 30.3 cm (17½ x 12 in.) Private collection

The excrement-soiled underpants of the figure on the right perturbed and "scanDalízed" the Surrealists, much to Dalís delight.

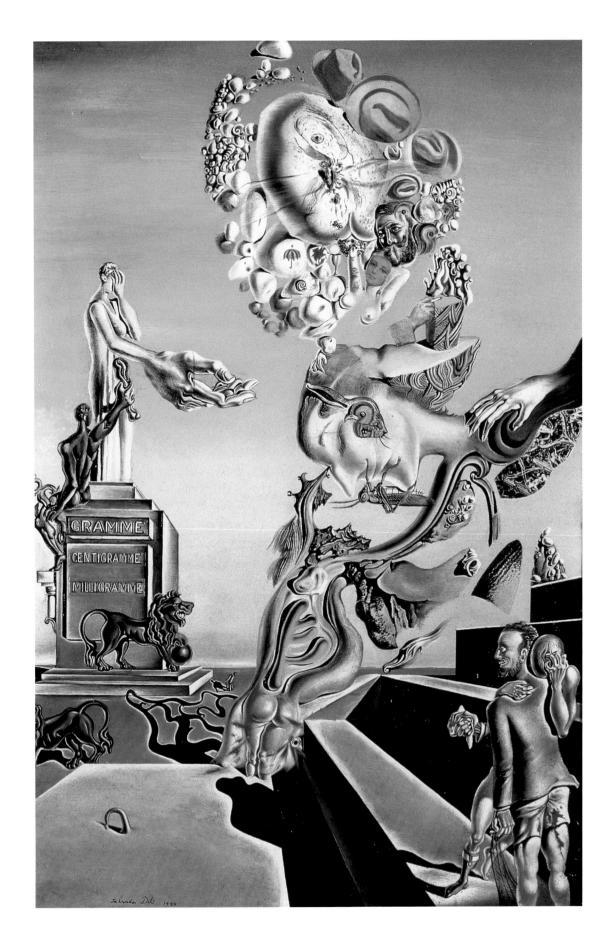

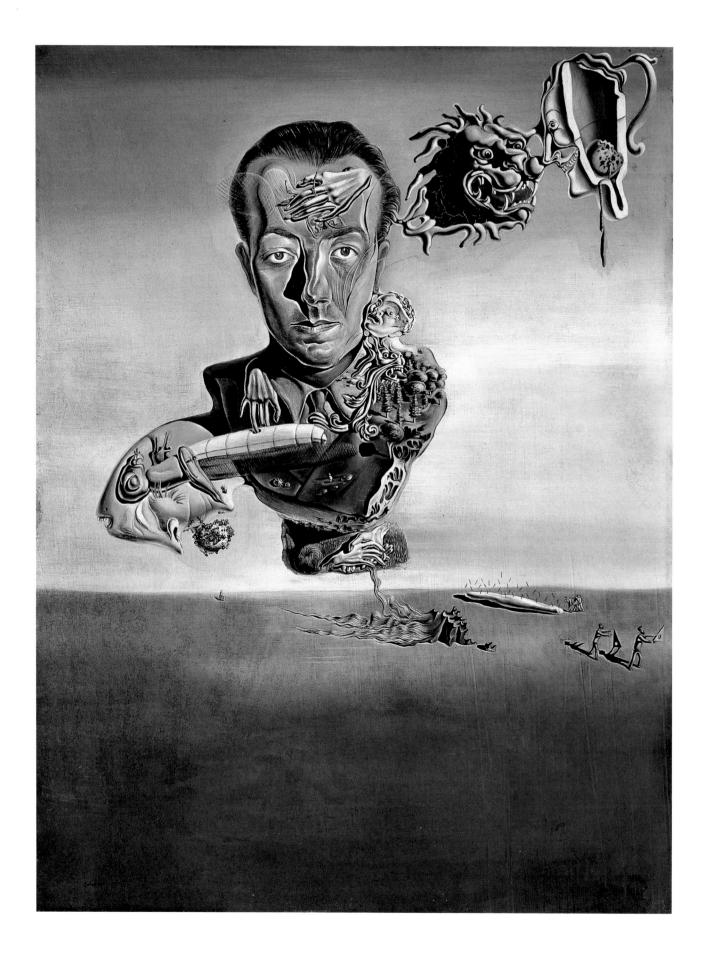

The Trial of Love

The phase of artistic borrowing, necessary for every beginner, was coming to an end. Dalí now felt a strong urge to create objects laden with contemporary sexual symbols. The works which subsequently emerged, such as *Honey Is Sweeter than Blood* (1926, p. 17) and *The Lugubrious Game* (1929, p. 19), which shows a figure soiled with excrement, created a scandal in Barcelona and raised Surrealist eyebrows in Paris. Dalí had only just turned twenty, and yet the maturity of his work was becoming evident. His new pictures contained a kind of genetic code which would give shape to all his later work.

Despite the scandal surrounding his name, the Catalan critics were enthusiastic and eager to see this new star painter take on the big neighbour, France. One of them wrote: "Seldom does a young painter present himself with so much aplomb as Salvador Dalí, a son of the town of Figueras ... If he now turns his gaze towards France it is because he has just what it takes ... What does it matter if to fan the flames he uses the fine pencil of Ingres or the rough wood of Picasso's Cubist works?"

The bait which Dalí had laid now began to attract the Surrealists, who were drawn to the young Catalan just as much by his extravagant personality as by the violence of his work, so full of sexual and scatological allusions. The businessman Camille Goemans sent him 3,000 francs for three paintings, which Dalí was to choose himself, and announced that he would exhibit all Dalí's pictures in his Paris gallery. And to crown everything there occurred the event which was to change Dalí's whole life: the visit of a party of Surrealists headed by Luis Buñuel and including René Magritte and his wife, and – most significantly – Paul Eluard and his wife Gala.

Dalí felt flattered by Paul Eluard's visit for, together with André Breton and Louis Aragon, Eluard was the mastermind of the Surrealist movement. Dalí had already met him briefly in Paris the previous winter, but now the young Catalan immediately began work on a portrait of Eluard which he enriched with various familiar allusions such as the head of a lion, ants and grasshoppers (p. 20). It was, however, the entrance of Gala into his world which represented the revelation Dalí had awaited for so long. Did she not embody the woman of his childhood dreams whom he had mythically christened "Galuchka" and later portrayed in the many young girls and adolescent women typified by *Girl with Curls* (1926, p. 13)? There was no mistaking her, for she possessed the same naked back.

Gala and Dalí
This photomontage by Dalí consists of a
photograph of the artist with shaved head
taken by Luis Buñuel, and a photograph of
Gala which Dalí took himself. It declared Dalí's
separation from his family and his indissoluble
union with Gala.

Portrait of Paul Éluard, 1929 Oil on cardboard, 33 x 25 cm (13 x 9¾ in.) Private collection

When Dalí began this portrait, Gala was still Eluard's wife. By the time he finished it, she no longer was.

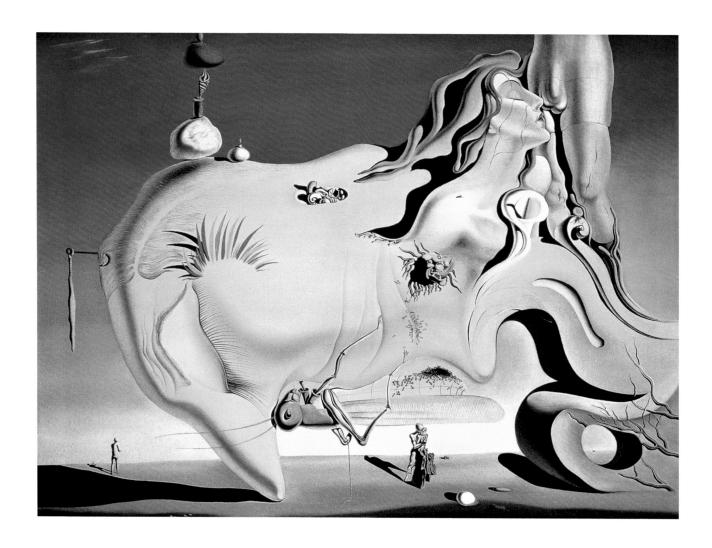

Face of the Great Masturbator/ The Great Masturbator, 1929 Oil on canvas, 110 x 150 cm (43¼ x 59 in.) Madrid, Museo Nacional Centro de Arte Reina Sofía. Dalí bequest

This picture bears witness to Dalí's first encounter with Gala and the state in which she left him – midway between "hard" and "soft".

Proof positive was the fact that her anatomy corresponded exactly to that of most of the female figures he had so far portrayed in his paintings and drawings. In his *Secret Life* he describes her thus: "Her body still had the complexion of a child's. Her shoulder blades and the sub-renal muscles had the somewhat sudden athletic tension of an adolescent's. But the small of her back, on the other hand, was extremely feminine and pronounced, and served as an infinitely svelte hyphen between the wilful, energetic and proud leanness of her torso and her very delicate buttocks which the exaggerated slenderness of her waist enhanced and rendered greatly more desirable."

It must be remembered that up to now Dalí had experienced scarcely more than a warm friendship with Lorca, a friendship which certainly continued to grow. There is no doubt that both young men found in each other a mutually intense passion for aesthetic discovery. Dalí experienced the poetic quest of his "lover" as an echo of his own artistic search. However, this friendship gradually gave way to amorous passion on the part of the poet from Granada, deeply troubling the young Catalan painter. Writing of this later in *Les Passions selon Dalí* he stated: "When García Lorca wanted to possess me, I refused in horror." Bearing in mind Dalí's capacity for inventing stories, we shall never know what really happened between these two young people. What is true, is that Dalí had a very limited experience of women at this time and one which fell far short of

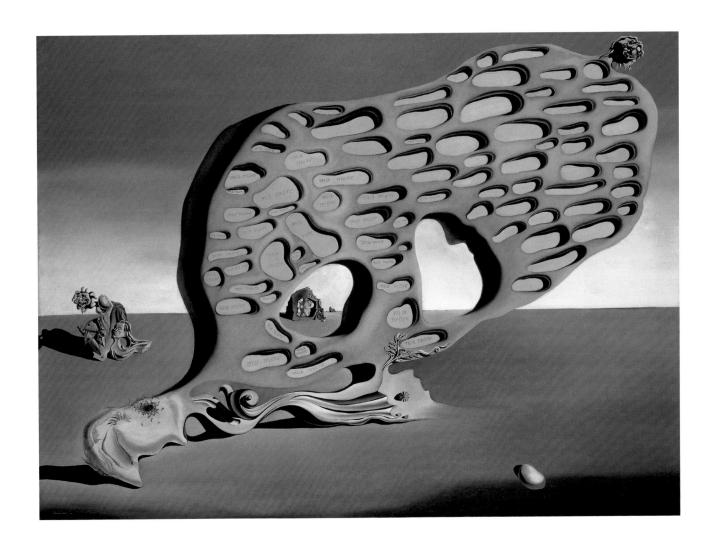

his fantasies, though this was of great benefit to his work. He always claimed that he was a virgin when he met Gala.

This historic meeting was accompanied by a fit of extreme madness. Dalí was in such a state of constant exaltation that every time he started to speak to Gala he burst into insane laughter. Whenever she left him he was convulsed by a fit of laughter and fell to the ground almost before she had turned her back.

His picture *The Lugubrious Game* (1929, p. 19) had alarmed the Surrealists with its underpants stained by excrement and had raised the question whether Dalí was coprophagic or not. In actual fact, the Surrealists had allowed themselves to be dazzled by this scatological detail, while for Dalí the soiled underpants were only one element among many designed to provoke a scandal – a function they fulfilled to perfection. Above all, however, the painting was a synthesis of all of Dalí's phobias and presented the typical Dalínian motifs: the grasshopper, the lion, the pebbles, the snail, the lips of the vulva. It is a magisterial statement of the "elementary biological character" of his future work.

Gala decided to put an end to the speculation and suggested a meeting. As they walked along the cliffs Dalí curbed his insane laughter. In response to her question he hesitated. "If I admitted … I was coprophagic … it would make me even more interesting and phenomenal in everybody's eyes." He decided to

The Enigma of Desire or Ma mère, ma mère, ma mère, 1929

Oil on canvas, 110.5 x 150.5 cm (43½ x 59¼ in.) Munich, Bayerische Staatsgemäldesammlungen, Pinakothek der Moderne

A homage to his mother, who, incidentally, never appears in his pictures. Here she takes the shape of a monstrous womb, resembling the weather-beaten rocks along the Cadaqués coast, which were another of Dalí's great loves and a source of inspiration for his fantasies.

Accommodations of Desire, 1929 Oil and collage on cardboard, 22.5 x 35 cm (8¾ x 13¾ in.) New York, The Metropolitan Museum of Art. Jacques and Natasha Gelman Collection

Dalí paints the forms taken, in his imagination, by the inhibitions of which Gala was slowly curing him.

The Invisible Man, 1929–32 Oil on canvas, 140 x 81 cm (55 x 31¾ in.) Madrid, Museo Nacional Centro de Arte Reina Sofía. Dalí bequest

Dalí considered this unfinished picture the "paranoiac fetish" protecting him and Gala. It is the counterpart to William Tell and at the same time the first of the double images which would subsequently recur throughout Dalí's oeuvre.

tell the truth: "I swear I am not 'coprophagic'. I consciously loathe that type of aberration as much as you can possibly loathe it. But I consider scatology a terrorizing element, just as I do blood, or my phobia of grasshoppers." The most difficult thing for Dalí was to tell her, between two bouts of nervous laughter, that he loved her. This was certainly no easy matter, for Helena Devulina Diakonoff, daughter of a Moscow official, whom everyone called Gala, was a woman whose fascinating charm and poise was bound to impress Dalí, and now that her body was so close to his, so real, he was speechless. "Victories, too, have faces darkened by frowns. So I had better not try to change anything!" Dalí reported. "I was about to touch her, I was about to put my arm round her waist, when with a feeble little grasp that tried to squeeze with the utmost strength of her soul, Gala's hand took hold of mine. This was the time to laugh, and I laughed with a nervousness heightened by remorse, which I knew beforehand the vexing inopportuneness of my reaction would cause me. But instead of being wounded by my laughter, Gala felt elated by it. For, with an effort which must have been superhuman, she succeeded in again pressing my hand, even harder than before, instead of dropping it with disdain as anyone else would have done. With her medium-like intuition she understood the exact meaning of my laughter, so inexplicable to everyone else. She knew that my laughter was altogether different from the usual 'gay' laughter. No, my laughter was not scepticism; it was fanaticism. My laughter was not frivolity; it was cataclysm, abyss, and terror. And of all the terrifying outbursts of laughter that she had already heard from me this, which I offered her in homage, was the

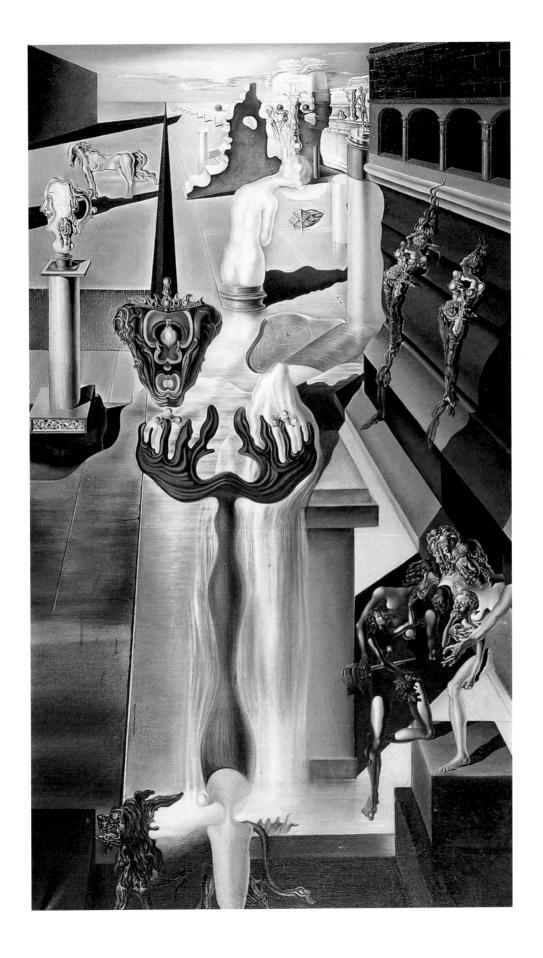

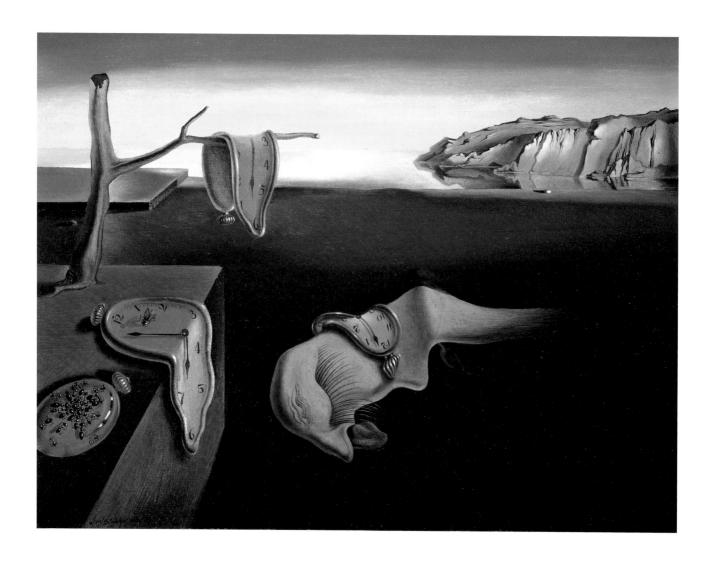

The Persistence of Memory, 1931 Oil on canvas, 24.1 x 33 cm ($9\frac{1}{2}$ x 13 in.) New York, The Museum of Modern Art

The famous "soft watches" stem from a dream about runny Camembert...

most catastrophic, the one in which I threw myself to the ground at her feet, and from the greatest height! She said to me, 'My little boy! We shall never leave each other."

Dalí himself gives the historical and Freudian key to the indissoluble love which had just been born and would dominate all his work, and which only death would terminate: "She was destined to be my Gradiva, 'she who advances', my victory, my wife. But for this she had to cure me, and she did cure me \dots solely through the heterogeneous, indomitable and unfathomable power of the love of a woman, canalized with a biological clairvoyance so refined and miraculous, exceeding in depth of thought and in practical results the most ambitious outcome of psychoanalytical methods." Dalí had just read Jensen's novel Gradiva, interpreted by Sigmund Freud in Delusion and Dreams (Der Wahn und die Träume). The eponymous heroine of the novel succeeds in healing the male protagonist psychologically. Dalí goes on to explain that "I knew I was approaching the 'great trial' of my life, the trial of love". Accommodations of Desire (1929, p. 24) gives an idea of this challenge, representing desire by lions' heads. Trembling, Dalí asked Gala: "What do you want me to do for you?' Then Gala, transforming the last glimmer of her expression of pleasure into the hard light of her own tyranny, answered, 'I want you to kill me!" Dalí noted: "One of the

lightning ideas that flashed into my mind was to throw Gala from the top of the bell-tower of the Cathedral of Toledo." But Gala, as was only to be expected, proved to be the stronger: "Gala thus weaned me from my crime, and cured my madness. Thank you! I want to love you! I was to marry her. My hysterical symptoms disappeared one by one, as by enchantment, I became master again of my laughter, of my smile, and of my gestures. A new health, fresh as a rose, began to grow in the centre of my spirit."

After accompanying Gala to the railway station in Figueras where she took a train to Paris, Dalí once again locked himself in his studio to complete the portrait for which Paul Eluard had posed (p. 20). Dalí felt himself most at home under the Catalonian sun, in the clear light of Cadaqués. Although he had still not made proper contact with the Surrealists, he already sensed a profound change coming over him. He now drew upon his supreme technical mastery of all that he had learned to start painting, with diabolical ease, the "trompe-l'oeil photographs" which would make him, a quarter century in advance, the patron saint of American photo-realists. Dalí, however, used photographic precision to transcribe the images of his dreams. This would become one of the constants in

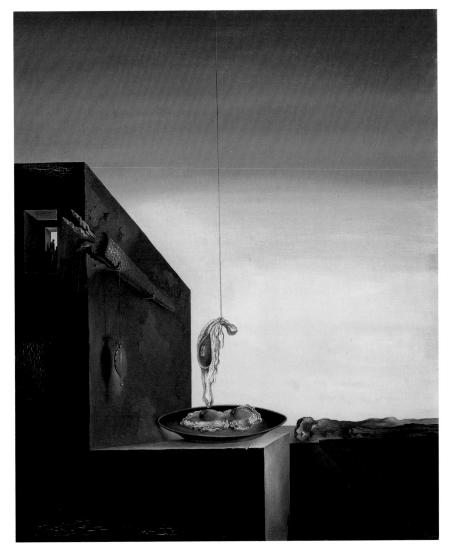

Eggs on the Plate (without the Plate), 1932 Oil on canvas, 60 x 41.9 cm (23½ x 16½ in.) St. Petersburg, Florida, The Salvador Dalí Museum

The "soft" egg, a favourite Dalínian motif, which he links to pre-natal images and the intra-uterine universe.

Catalan Bread/Anthropomorphic Bread, 1932 Oil on canvas, 24 x 33 cm (9½ x 13 in.) St. Petersburg, Florida, The Salvador Dalí Museum

Some examples of the "hard" and "soft" that were meant to shock the Surrealists, not to mention the "counter-revolutionary act" of giving William Tell (the father figure) the face of Lenin.

his work, and his first efforts in this direction can be described as the overture to his Surrealist paintings. In 1973, having improved upon his earlier definition, he continued to speak of his work as "hand-painted colour photography of super-fine images of concrete irrationality". It was in this spirit that he started on a major painting that was to become very famous indeed: The Great Masturbator (1929, p. 22). The composition is based on a chromolithograph of a woman smelling a lily; in Dalí's hands, however, it inevitably assumes an entirely different meaning. At the same time, it mingles fresh memories of his momentous meeting with Gala with recollections of Cadaqués, the summer and the rocks of Cape Creus. "It represented a large head," he wrote, "livid as wax, the cheeks very pink, the eyelashes long, and the impressive nose pressed against the earth. This face had no mouth, and in its place was stuck an enormous grasshopper. The grasshopper's belly was decomposed, and full of ants ... the head terminated in architecture and ornamentations of the style of 1900." The Great Masturbator is a sort of "soft" self-portrait (Dalí had a whole theory about "softness" and "hardness", which formed the foundation of his aesthetic and which he summed up in the formula: "the perfect life of degenerate morphology"), in which Dalí is visibly exhausted, as soft as a wad of chewing tobacco; ants and a harvest-spider run over his face. But this look of suffering finds an explanation in the face of a woman positioned for fellatio: with Gala he had experienced ecstasy!

Despite the fact that Dalí often claimed to be "to-tal-ly im-po-tent", there can be no denying that, in some of his pictures at least, he seems to be in the best of form. *Atmospheric Skull Sodomizing a Grand Piano* (1934, p. 30) is one such case, and viewed from this angle takes on an interesting new light. It should be remembered that, for Dalí, a grand piano is female, whereas "musicians are cretins and even super-gelatinous cretins". A third picture completes the spectrum of Dalínian sexual performance: *The Fine and Average Invisible Harp* (c. 1932, p. 32), painted after a photograph taken by the painter at Portlligat, in which Gala can be seen walking away with her buttocks still exposed, while the "erectile, budding head" of the figure in the foreground rests on a crutch as if

William Tell is the figure of the father who banishes the Salvador-Gala couple. Eroticism triumphantly overpowers him, however, as witnessed by the drawings of the same period. Ironically, Dalí used the money from the sale of this painting to buy his fisherman's hut at Cadaqués and, with it, his independence.

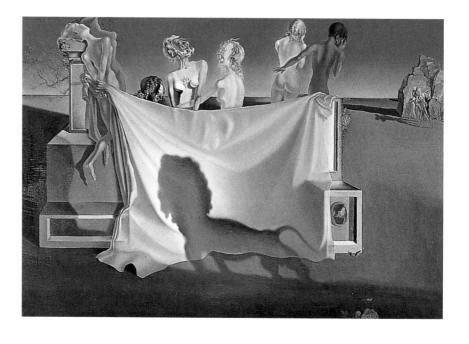

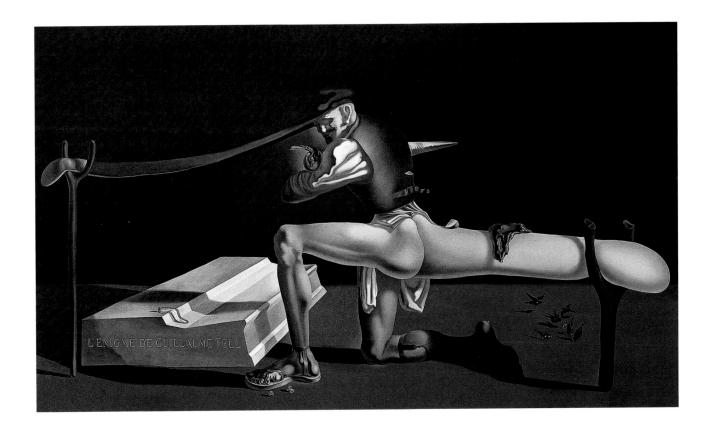

after coitus. Simultaneously hard and soft, it represents the sexual instinct as intellectualized and sublimated by art. The crutch and the monstrous outgrowth of cerebralized sexuality and imaginative intelligence, swollen with vitality, are at the same time symbols of death and resurrection – like the love act itself, which rises again from its own ashes *ad infinitum*. In *Meditation on the Harp* (*c.* 1933, p. 33) the crutch is first and foremost a symbol of reality: an anchor in the ground of the real world which keeps the monstrous burgeoning of sexuality in balance. The crutch is also the symbol of tradition, which upholds essential human values against the earthquakes of individual reactions and collective revolutions (Jean Bobon).

In this period, dominated by the entry of Gala into his world and the beginning of her ascendancy, the sexual mutations taking place in Dalí's life overflow into his art. They find expression in "hard" and "soft" images – sometimes opposed, at other times complementary. Dalí compiles a veritable anthology of examples, which he marries happily with the omnipresent culinary atavism of his Catalan roots: in *Eggs on the Plate (without the Plate)* (1932, p. 27), for example, a favourite motif which Dalí connected with pre-natal images and the universe of the womb; in *The Persistence of Memory* (1931, p. 26); or in *Anthro-pomorphic Bread* (1932, p. 28), which presents an image both aggressively phallic and threatening to go limp with time (the soft watch).

The Enigma of Desire (1929, p. 23) similarly belongs to the turbulent period following his legendary meeting with Gala. It was, incidentally, the first of his pictures to be sold at the Galerie Goemans. The Vicomte de Noailles, who was to become a loyal friend and one of Dalí's first collectors, purchased it together with *The Lugubrious Game* (1929, p. 19). In the baroque decorations which form

The Enigma of William Tell, 1933 Oil on canvas, 201.3 x 346.5 cm (79¼ x 136½ in.) Stockholm, Moderna Museet

the extension to the head in *The Enigma of Desire*, the geological structures of the weathered rocks around Cape Creus mingle with influences from the fantastical architecture of Antoni Gaudí, whose "Mediterranean Gothic" Dalí had admired since childhood.

Dalí did not attend the opening of his first exhibition in Paris in 1929; instead, he eloped with Gala. Madly in love, they left two days before the vernissage for Barcelona and Sitges, a small seaside resort just south of the Catalan capital. Before leaving they caught the screening of *Un Chien Andalou*, which Buñuel had finally finished cutting. It would seal their reputations. Eugenio Montes called it "a red-letter day in the history of the cinema, a sign of the times drawn in blood, such as Nietzsche desired and such as Spain has always provided." Dalí was exultant and noted in *The Secret Life*: "The film produced the effect I wanted ... Our film ruined in a single evening ten years of pseudo-intellectual post-war avant-gardism. That foul thing figuratively called abstract art fell at our feet, wounded to the death, never to rise again, having seen a girl's eye cut by a razor-blade – this was how the film began. There was no longer room in Europe for the little maniacal lozenges of Monsieur Mondrian."

But clouds were gathering above the idyll, interrupting the honeymoon during which they had been preoccupied solely with their bodies. Dalí left Gala behind, "the vigilant helmsman holding the rudder of our life's boat", first to collect the money from Goemans (for almost all his pictures had sold, at prices ranging from 6,000 to 12,000 francs) and, most important, to face the storm that was raging at the family home in Figueras.

Doubtless out of respect for his father, for a long time Dalí had made a secret of the reasons for the breach within his family and his expulsion from it. The picture *The Enigma of William Tell* (1933, p. 29), of which he later gave an interpretation, offers the first clues. As always with Dalí, we are faced with a precisely functioning machine. "William Tell is my father and the little child in his arms

Atmospheric Skull Sodomizing a Grand Piano, 1934 Oil on wood panel, 14 x 17.8 cm (5½ x 7 in.) St. Petersburg, Florida, The Salvador Dalí Museum

Dalí: "The obsession, according to which the jaws are the most philosophic instruments that man possesses. The lyricism of the piano is brutally possessed by the jaws of a fossil skull. This vision is a retinian product, a hypnogogic image of pre-sleep, occurring in the course of a siesta, contrary to the images resulting from the effects of mescalin, which can never reproduce instantaneous memories."

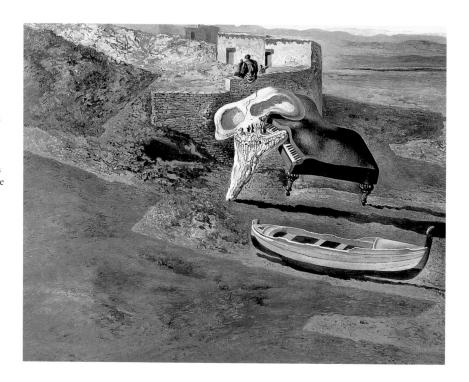

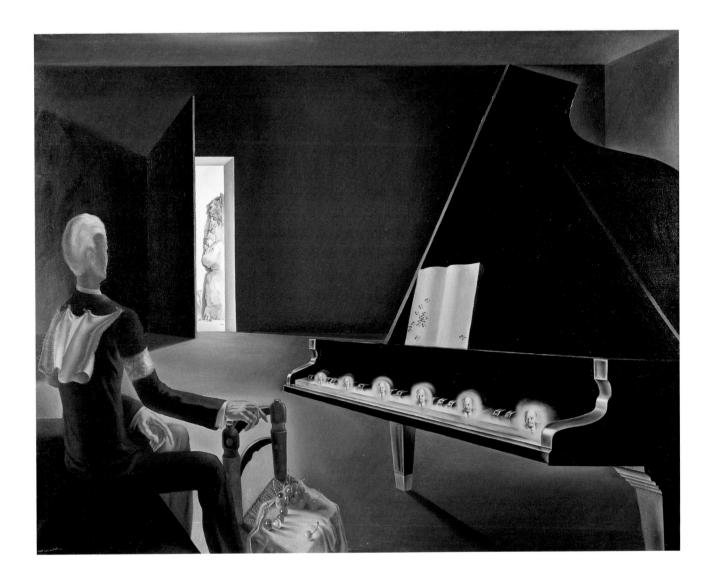

is myself; instead of an apple I have a raw cutlet on my head. He is planning to eat me. A tiny nut by his foot contains a tiny child, the image of my wife Gala. She is under constant threat from this foot. Because if the foot moves only very slightly, it can crush the nut." With this picture Dalí settled accounts with the father who had disowned him for living with a divorcee, the former wife of Paul Eluard. But nothing was ever simple with Dalí, for on this occasion he deliberately gave William Tell the face of Lenin – with the sole aim of provoking the fury of the Surrealists. With great success: when he submitted the painting for exhibition in the 1934 Salon des Indépendants, André Breton was outraged; he considered the picture a "counter-revolutionary act" and treason against the Bolshevik leader. The Surrealist pope and his friends even attempted to destroy it; fortunately it hung so high that it escaped their vandalism.

The second reason for Dalí's breach with his father no doubt lay in a gesture with which Dalí had intended to shock the Surrealists. During the few days he spent in Paris in November, Dalí had shown members of the group a devotional chromolithograph depicting the Sacred Heart, which he had bought at the Rambla in Figueras. Across the picture Dalí had scrawled: "Sometimes I spit on

Hallucination. Six Images of Lenin on a Grand Piano/Partial Hallucination. Six Images of Lenin on a Grand Piano, 1931 Oil on canvas, 114 x 146 cm (44¾ x 57½ in.) Paris, Musée national d'art moderne, Centre Pompidou

According to Dalí this is a "hypnogogic picture" whose genesis he describes as follows: "At sunset. I saw the bluish, shiny keyboard of a piano, where the perspective exposed to my view a series in miniature of little yellow, phosphorescent halos surrounding Lenin's visage."

The Spectre of Sex-Appeal, c. 1934 Oil on wood panel, 17.9 x 13.9 cm (7 x 5½ in.) Figueras, Fundación Gala-Salavador Dalí

Also known as *The Spectre of Libido*. Dalí felt as dwarfed by this monster as the small child in the sailor suit who represents him. And yet one cannot help but notice the hoop, a female symbol, in the child's left hand, and a very phallic-looking femur in his right.

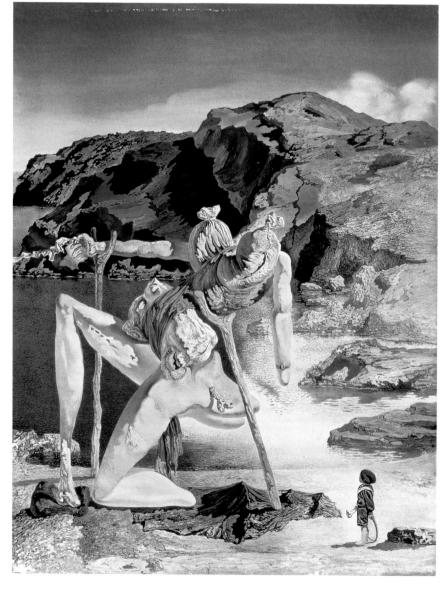

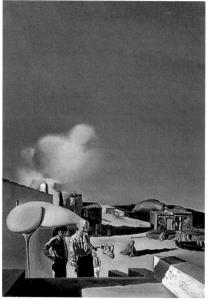

The Fine and Average Invisible Harp, c. 1932 Oil on canvas, 21 x 16 cm $(8\frac{1}{4} \times 6\frac{1}{4} \text{ in.})$ Private collection

the portrait of my mother for the fun of it." The Spanish art critic Eugenio D'Ors published an article about this sacrilege in a Barcelona daily paper. Dalí's father was so outraged by his son's blasphemy, which he took quite literally as an insult to the memory of his dead wife and Dalí's beloved mother, that he never forgave him this shameful episode. Dalí said in his own defence: "In a dream, one can commit a blasphemous act against people one adores in real life and dream of spitting on one's mother ... In some religions the act of spitting often takes on a sacred character." But it was an explanation which even the most openminded Figueras notary would have found difficult to accept.

Dalí's father told everybody: "Don't worry. He's not at all practically minded and he can't even buy a cinema ticket. In a week at the most he'll be back in

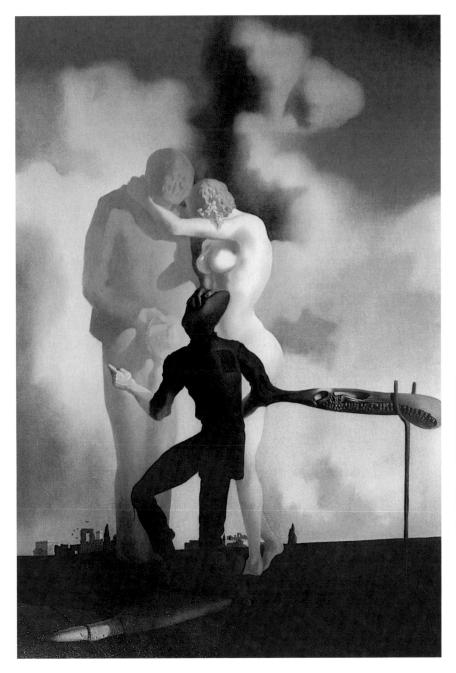

Meditation on the Harp, c. 1933 Oil on canvas, 67 x 47 cm (26¼ x 18½ in.) St. Petersburg, Florida, The Salvador Dalí Museum

Examples of monstrous outgrowths of intellectualized sexuality aud of a sexually swollen imaginative intelligence, which only a sturdy crutch can support and anchor in the real world.

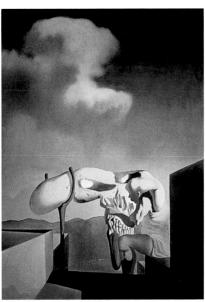

Figueras, covered in lice and begging my forgiveness." But he had not reckoned with Gala and her clear-sighted perseverance. Instead of turning up covered in lice, Salvador was later to return covered in glory. Vanquishing his father he had become a hero. In his *Diary of a Genius* Dalí quotes Freud's definition: "The hero is the man who resists his father's authority and overcomes it." Despite the admiration Dalí felt for his father's charisma and the humanity he emanated, he had to make the break and turn his back on adolescence. But since he loved his white-washed village under the sun and refused to countenance any other landscape, he simply had to return as soon as possible. In a sheltered bay near Cadaqués, at Portlligat (which means "port secured with a knot"), he bought the most tumbledown fisherman's hut. By an irony of fate, he purchased it with

Average Atmospherocephalic Bureaucrat in the Act of Milking a Cranial Harp, c. 1933 Oil on canvas, 22.2 x 16.5 cm (8¾ x 6½ in.) St. Petersburg, Florida, The Salvador Dalí Museum

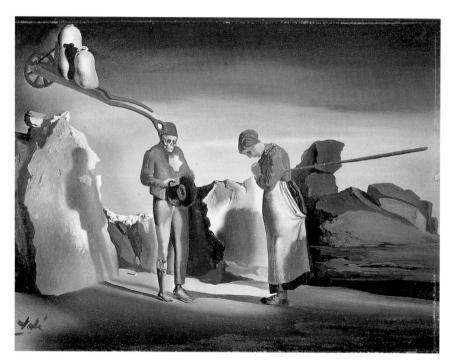

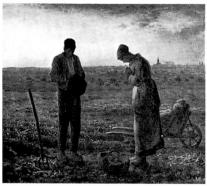

ABOVE LEFT Jean François Millet *The Angelus*, 1857–59 Oil on canvas, 55.5 x 66 cm (21¾ x 26 in.) Paris, Musée d'Orsay

ABOVE RIGHT

Atavism at Twilight (Obsessional

Phenomenon), c. 1933

Oil on wood panel, 13.8 x 17.9 cm (5½ x 7 in.)

Berne. Kunstmuseum Bern

the money he had received for *The Old Age of William Tell* (1931, p. 28). This picture again presents an image of his father, this time banishing Salvador and Gala from his sight, a reference to the rupture within the family and the beginning of the long love story which from now on Dalí would illustrate in canvas after canvas, painting the "mythological" story of "our lives together".

Once he realized that the breach was irreparable and that he had been banished from his father's house, Dalí reacted by cutting off his hair, as if covering his head with ashes. A symbol of this event is to be found in a photomontage (p. 21) combining a picture of Dalí with shaved head, taken by Buñuel in 1929, with a photograph of Gala taken by Dalí in 1931. Dalí created the montage for the frontispiece of his book *L'Amour et la mémoire*, published in 1931 by the Editions Surréalistes in Paris. In *The Secret Life* Dalí writes: "I had my head completely shaved. I went and buried the pile of my black hair in a hole I had dug on the beach for this purpose, and in which I interred at the same time the pile of empty shells of the urchins I had eaten at noon. Having done this I climbed up on a small hill from which one overlooks the whole village of Cadaqués, and there, sitting under the olive trees, I spent two long hours contemplating that panorama of my childhood, of my adolescence and of my present."

In contrast to Maillol, Miró and Picasso, who all went into exile, this panorama always remained a place of refuge for Dalí, even though he described it as "one of the most arid ... spots on the earth. The mornings are of a savage and bitter, ferociously analytical and structural gaiety: the evenings often become morbidly melancholy." This landscape appears in his pictures time and time again with all the sharpness of pain: it resurfaces in titles such as *Geological Destiny* (1933, p. 37), in which a solitary horse bearing two skulls is "in the process of transformation into rock in the middle of the desert". It underlies, too, his fascination with Millet's *The Angelus* (1857–59, p. 34), which he explored in

a succession of different ways – as an "architectonic" composition (1933, p. 36); as an evocation of a particular kind of *Atavism at Twilight* (*c.* 1933, p. 34); and under the title *Archaeological Reminiscence of Millet's "Angelus"* (*c.* 1934, p. 35). He explained that "in a brief fantasy I indulged in a walk to Cape Creus, the stony landscape of which is a true geological delirium, I imagined the two sculptured figures of Millet's *The Angelus* hewn out of the highest cliffs. Their position in space was the same as in the picture but they were furrowed with deep fissures. Many parts of both figures had been worn away by erosion, which helped to reconstruct their origins in a distant past contemporary with the origin of the rocks themselves. Time had worn particularly hard on the man, rendering him unrecognizable, leaving only the vague, shapeless block of the silhouette, which thus became alarming and especially frightening" (*The Tragic Myth of Millet's "Angelus"*).

Whenever funds were at a low ebb, either because the Galerie Goemans had gone bankrupt or because the Vicomte de Noailles (Dalí's regular patron) had become a little too enamoured of abstract art, Salvador and Gala retreated to Cadaqués, leaving Paris behind them "bubbling like a witch's cauldron". On his

Archaeological Reminiscence of Millet's "Angelus", c. 1934
Oil on wood panel, 31.75 x 39.4 cm (12½ x 15¼ in.)
St. Petersburg, Florida,
The Salvador Dalí Museum

Dalí's homages to Millet stemmed from childhood memories of a calendar on a classroom wall and grew from his contemplation of the rocks at Cape Creus.

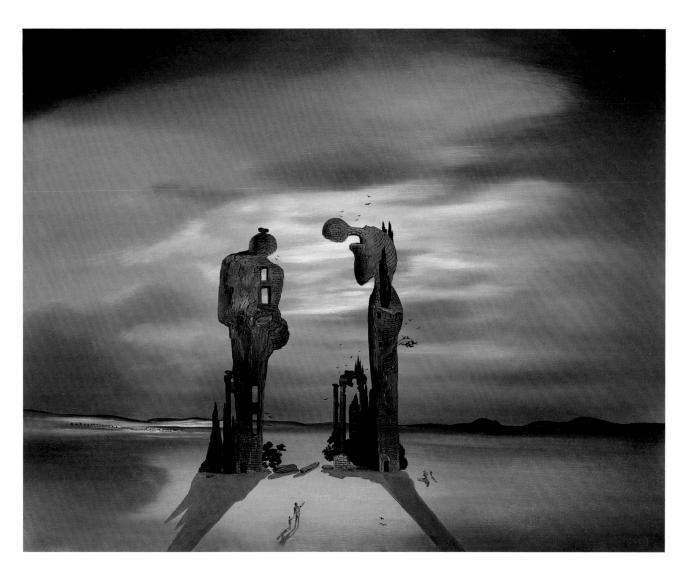

Millet's Architectonic "Angelus", 1933 Oil on canvas, 73 x 60 cm (28¾ x 23½ in.) Madrid, Museo Nacional Centro de Arte Reina Sofía

The Tragic Myth of Millet's "Angelus" is one of Dalí's most profound fantasies. Confirming Dalí's own interpretation of the picture, an X-ray examination of Millet's canvas has revealed a geometrical shape between the two figures, the coffin of their dead child. According to Dalí, the woman's seemingly submissive stance merely indicates a lull before the act of aggression, like that of a praying mantis before copulation. The wheelbarrow, a female object, figures as such in many popular representations of rural eroticism.

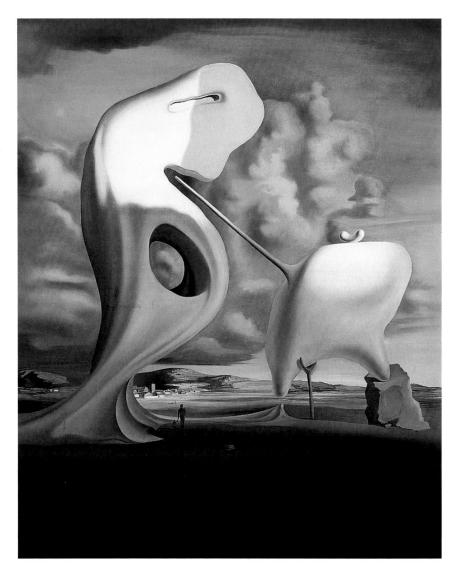

short visits to the metropolis Dalí never failed to toss a few "words of ideological significance" into the "cauldron".

His greatest wealth during this period – before Salvador Dalí had become the "Avida Dollars" of Breton's clever anagram – was Gala. She followed him everywhere, defended and protected him against others and against himself. "The idea that in my own room where I was going to work there might be a woman, a real woman who moved, with senses, body hair and gums, suddenly struck me as so seductive that it was difficult for me to believe this could be realized."

Geological Destiny, 1933 Oil on wood panel, 21 x 16 cm (8¼ x 6¼ in.) Private collection

Like the figures of *The Angelus*, this solitary horse has begun to turn to rock.

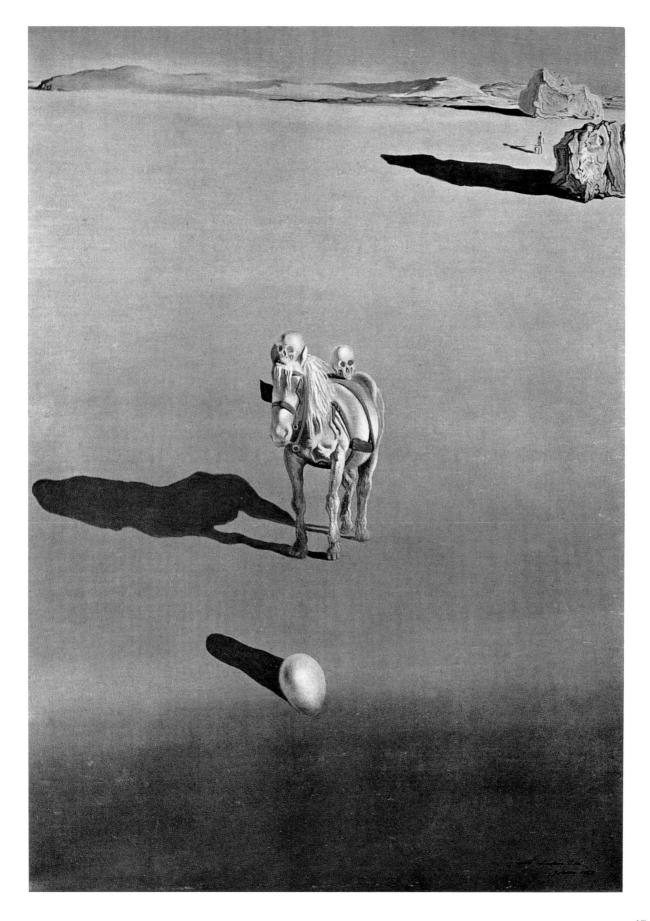

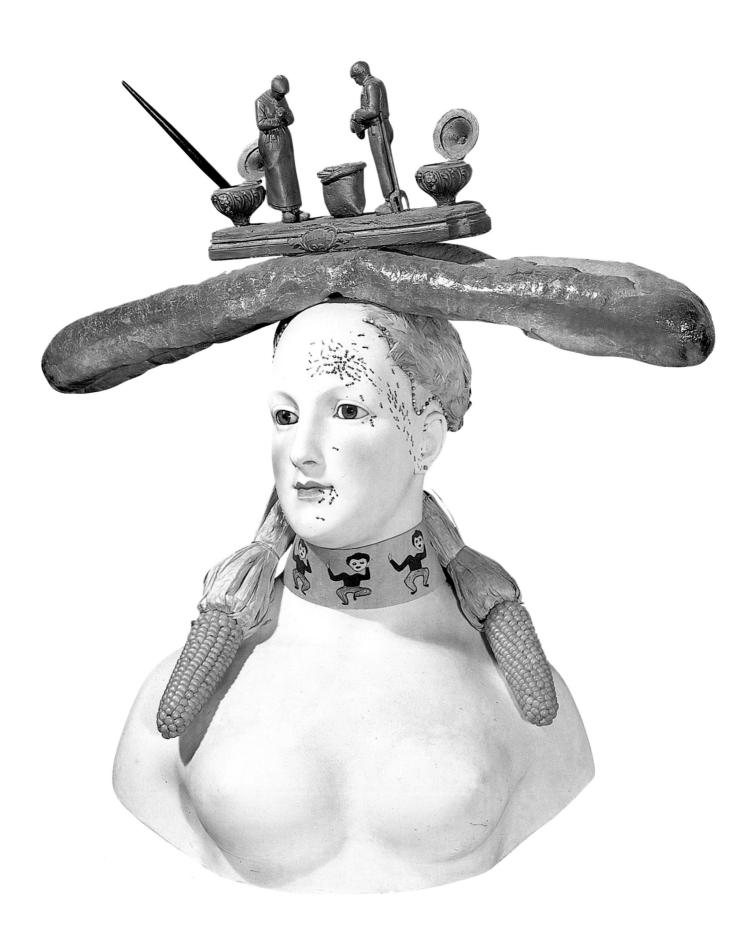

The Triumph of Avida Dollars

"We must go to Paris and get our hands on the money we need to finish the work on our Portlligat house" ... and that meant they would have to "make thunder and rain. But this time it's going to be gold!" Because of the "free-masonry of the modern art scene", sales of Dalí's pictures proceeded only sluggishly. He therefore began to gather ideas for new products, many of which, alas, were eventually to be marketed by other people: false fingernails with small mirrors to look at oneself; transparent display dummies that could be filled with water in which fish swam, imitating the circulation of the blood; bakelite furniture moulded to the shape of the purchaser's body; false additional breasts for the back which could have revolutionized the fashion market for a hundred years; a whole catalogue of aerodynamic forms for motor cars, forms adopted ten years later by all car-makers ... Every day Gala set out to try and sell these inventions and every day she returned exhausted, "quite green about the gills, half-dead with fatigue and made more beautiful by the sacrifice of

Retrospective Bust of a Woman, 1933 (some elements reconstructed 1970) Painted porcelain, bread, corn, feathers, paint on paper, beads, ink stand, sand, and two pens), 73.9 x 69.2 x 32 cm (29 x 27¹/4 x 12 ⁵/8 in.) New York, The Museum of Modern Art

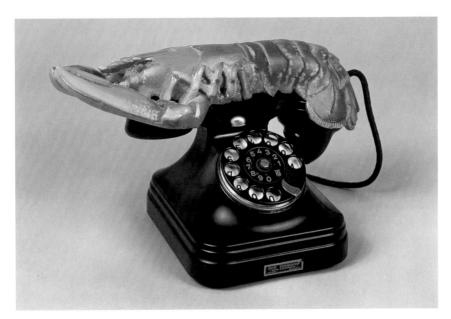

Lobster Telephone, 1936 Mixed media, including steel, plaster, rubber, resin and paper, 17.8 x 33 x 17.8 cm (7 x 13 x 7 in.) London, Tate

These "Surrealist objects functioning symbolically" are made up, as philosophers Deleuze and Guattari might today put it, of "partial objects" seeking to come together to form "wishing machines". For Dalí, the telephone was a broadcaster of news, while Hitler on a plate symbolized the fearful premonition that seized the world after the Munich conference.

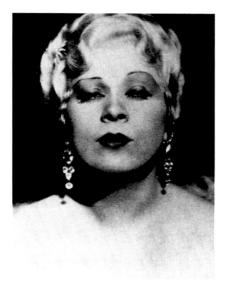

Photograph of Mae West prior to being retouched by Dalí, 1934–35

Mae West Lips Sofa, c. 1936 Wooden frame upholstered in dark and light pink felt, 92 x 213 x 80 cm (36 x 83¾ x 31½ in.) Brighton, Royal Pavilion Art Gallery & Museum

Working from a photograph of Hollywood star Mae West, Dalí designed the installation of a whole apartment, including the famous *Mae West Lips Sofa*, of which several examples were made. For fashion designer EIsa Schiaparelli he invented "shocking pink", the colour in which the sofa was upholstered and which sparked a new vogue. He also designed hats, ties and edible buttons, and clothes featuring real lobsters and real mayonnaise.

Elsa Schiaparelli Hat designs inspired by Dalí: cutlet hat, shoe hat, inkwell hat, 1937

Mae West's Face which May Be Used as a Surrealist Apartment, 1934–35 Gouache on newspaper, 31 x 17 cm (12¼ x 6¾ in.) The Art Institute of Chicago her passion". Everywhere people found such ideas either "insane" or practicable only at an "insane" price. And yet a large majority of them have since been turned into reality.

Dalí was enormously active throughout this period. He exhibited in America, wrote poems and contributed to the reviews *Le Surrealisme au Service de la Révolution* and *Minotaure*. In the latter he published his famous article "On the Terrifying and Edible Beauty of Modern Style Architecture", which discusses Art Nouveau architecture and concludes with the equally famous declaration: "Beauty will be edible or there will be no such thing at all." Above all, though, it was the film *L'Age d'Or (The Golden Age)* that created yet another scandal. Dalí wrote the screenplay in collaboration with Luis Buñuel, but the two friends were no longer on the same wavelength. Dalí wanted lots of bones, monstrances, and archbishops bathing amongst the rocky cataclysms of Cape Creus. Buñuel, "with his naïveté and his Aragonese stubbornness, deflected all this toward an elementary anticlericalism." Even so, Dalí was more talked about than ever

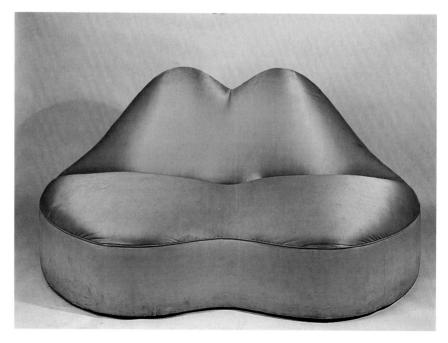

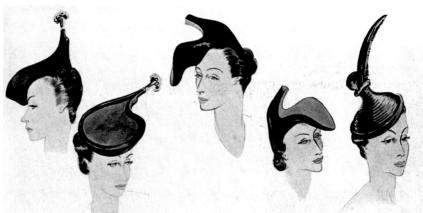

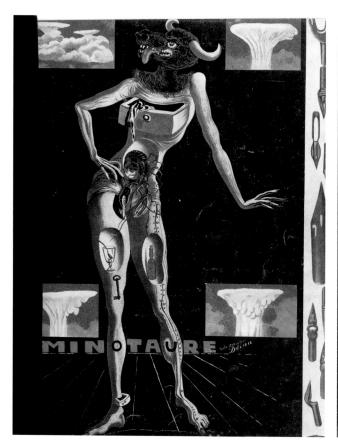

ABOVE LEFT
Cover of *Minotaure* no. 8, 1936
Oil and collage on cardboard,
33 x 26.5 cm (13 x 10½ in.)
Private collection

ABOVE RIGHT **Woman with Drawers**, 1936 Gouache on black paper, 35 x 27 cm (13¾ x 10½ in.) Private collection

Design for the cover of the catalogue accompanying the Dalí exhibition at the Julien Levy Gallery.

He conceived the plan of baking a fifteen-metre symbolic loaf and placing it in the gardens of the Palais Royal; this would be followed by a twenty-metre loaf at Versailles, and then thirty-metre loaves in all the cities of Europe. What a feast for the journalists that would be! The avowed aim of these demonstrations was to make fools of everyone and systematically subvert logic. All these inventions were the product of his "paranoiac-critical method", even though Dalí later admitted that at the time he did not quite realize the possibilities of his discovery. Nevertheless, Breton was soon to welcome it.

In *The Secret Life* Dalí gives several examples of actions resulting from his famous "method". The method was "beyond his comprehension" then – as with many of his discoveries he did not grasp its full significance until later. "One day I hollowed out entirely an end of a loaf of bread, and what do you think I put inside it? I put a bronze Buddha, whose metallic surface I completely covered with dead fleas. I closed the opening with a little piece of wood, on which I wrote 'Horse Jam'. What does that mean, eh?"

Another example: "One day I received a present from my very good friend Jean-Michel Frank, the decorator: two chairs in the purest 1900 style. I immediately transformed one of them in the following fashion. I changed its leather seat for one made of chocolate; then I had a golden Louis XV door-knob screwed under one of the feet, thus extending it and making the chair lean far over to its right, and giving it an unstable balance ... One of the legs of the chair was to repose continuously in a glass of beer ... I called this dreadfully uncomfortable chair, which produced a profound uneasiness in all who saw it, the 'atmospheric chair'. And what does that mean, eh?"

What it meant first and foremost was that the Surrealists began to worry: this Salvador Dalí seemed to be setting out to cut the ground out from under their feet and to launch a new breed of "Surrealist objects functioning symbolically", counter to traditional Surrealist automatic writing and narration of dreams. From the Lobster Telephone (1936, p. 39) to the Mae West Lips Sofa (1936-37, p. 40), Dalí's Surrealist objects achieved fame all over the world, and Dalí was not slow to add his commentaries. Thus, according to him, the Aphrodisiac Jacket (c. 1936, p. 43) fell into the category of "thinking machines". "It is a dinner jacket covered with liqueur glasses containing 'peppermint' liqueur; endowed, it seems, with vague aphrodisiac virtues. This jacket has the arithmetical advantage of calculations and paranoiac-critical number games capable of being evoked by the anthropomorphic position of the glasses. The myth of Saint Sebastian offers us a similar case: objective and measurable pain thanks to the number and position of the arrows; the pain felt by Saint Sebastian may be evaluated. It may be worn during certain promenades late at night, or in very powerful cars going very slowly (in order not to spill the liquid in the glasses) during certain very calm and very sentimentally compromising nights." Of Night and Day Clothes of the Body (1936, p. 43) he said: "One is unaware that this suit becomes skin, envelope, indeed armour or window; provided with a zipper, it may be opened wide by turning the bolt." At any rate it is very erotic, like most of the costumes created by Dalí. It is also an object of reflection. Later, the artist was to say during an interview that the tragic constant of human life was fashion, which was why he so much enjoyed working with Madame Chanel and Madame Schiaparelli. He believed that the concept of dressing was a consequence of the most powerful trauma of all, the trauma of birth. He also felt that fashion was a tragic constant of history: to watch models parading past was to watch angels of death heralding the approach of war.

Aphrodisiac Jacket, c. 1936 Smoking jacket with liqueur glasses, shirt and plastron on coat hanger, 77 x 57 cm (30½ x 22½ in.) (destroyed)

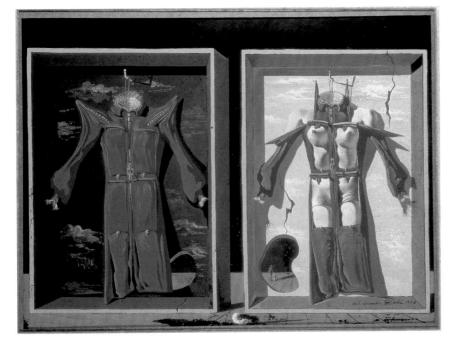

Night and Day Clothes of the Body, 1936 Gouache on paper, 30 x 40 cm (11% x 15% in.) Private collection

The kind of utterly useless invention (intended only for very rich snobs) that made Aragon fly into a rage. According to Dalí's instructions, this "St. Sebastian" jacket (on which the arrows have been replaced by liqueur glasses filled with crème de menthe, supposedly a mild aphrodisiac) was to be worn only "during certain promenades late at night, or in very powerful cars going very slowly (in order not to spill the liquid in the glasses)". Night and Day Clothes of the Body allow wearers to bare themselves to the sun while participating in winter sports and, simultaneously, to sensuous pleasures ...

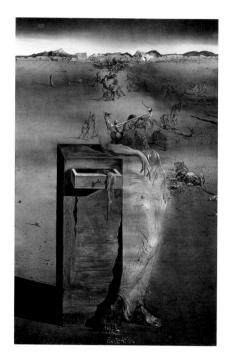

Spain, 1938 Oil on canvas, 92 x 60 cm (36¼ x 23½ in.) Rotterdam, Museum Boijmans Van Beuningen

Drawers could also release a different, nauseating type of smell from a strange kitchen – war. "From all parts of martyred Spain rose a smell of incense, of chasubles, of burned curates' fat and of quartered spiritual flesh, which mingled with the smell of hair dripping with the sweat of promiscuity from that other flesh, concupiscent and as paroxysmally quartered, of the mobs fornicating among themselves and with death."

Cupboards and drawers also interested him, and his works from these years are full of them: The Anthropomorphic Cabinet (1936, p. 44), Burning Giraffe (c. 1937, p. 45), and Venus de Milo with Drawers (1936, p. 45), for example. Dalí borrowed these drawers from Sigmund Freud. He used them to represent the psychoanalytical theories of the Viennese professor in pictorial images. He met Freud only once, in London in 1938, using the opportunity to show him Metamorphosis of Narcissus (1937, pp. 52-53) and to execute his portrait from memory. In another portrait sketch from the same period, he sees Freud's skull as a snail's shell. Of Freud's theories he said: "They are a kind of allegory destined to illustrate a certain forbearance, to scent out the countless narcissistic smells that waft out of all our drawers." He later added: 'The only difference between immortal Greece and the present time is Sigmund Freud, who discovered that the human body – purely Neoplatonic in the Greek age – is today full of secret drawers which only psychoanalysis is capable of opening." Thus Dalí opened the way for many artists, from Bellmer to Allen Jones, allowing them to play with dolls and transform women into chairs or tables.

But drawers could also release a different, nauseating type of smell from a strange kitchen – war. In *The Secret Life*, Dalí wrote: "From all parts of martyred Spain rose a smell of incense, of chasubles, of burned curates' fat and of quartered spiritual flesh, which mingled with the smell of hair dripping with the sweat of promiscuity from that other flesh, concupiscent and as paroxysmally quartered, of the mobs fornicating among themselves and with death." Of his *Soft Construction with Boiled Beans (Premonition of Civil War)* (1936, p. 47) he wrote: "The foreboding of civil war haunted me. As the painter of intestinal paroxysms I completed my picture *Premonition of Civil War* six months before the outbreak of war in Spain. This picture, garnished with boiled beans, shows a vast human body breaking out into monstrous excrescences of arms and legs tearing at one another in a delirium of auto-strangulation. The title *Premonition of Civil War*, which I gave the picture six months before war broke out, once again showed the truth of Dalí's prophecies."

The Surrealists were justifiably alarmed and offended by Dalí's bombastic inventions, for he was beginning to see himself as the only authentic representative of the movement. That at least is what he declared during his first visit

City of Drawers/
The Anthropomorphic Cabinet, 1936
Oil on wood panel,
25.4 x 44.2 cm (10 x 17½ in.)
Düsseldorf, Kunstsammlung
Nordrhein-Westfalen

In Freudian theory, the drawers of the unconscious stand for "a kind of allegory destined to illustrate a certain forbearance, to scent out the countless narcissistic smells that waft out of all our drawers."

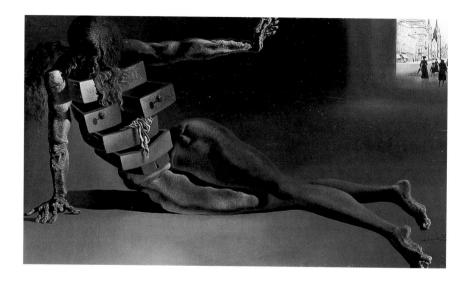

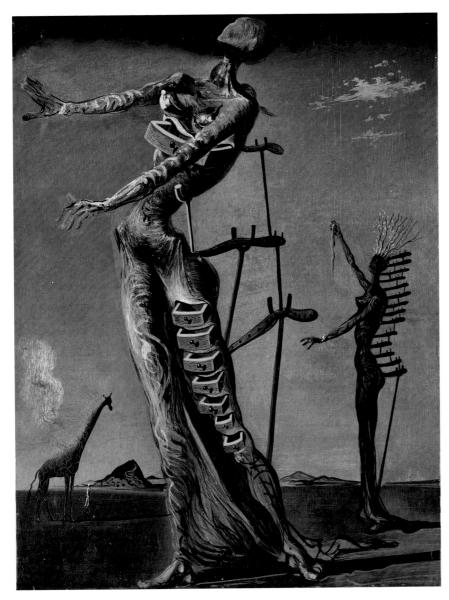

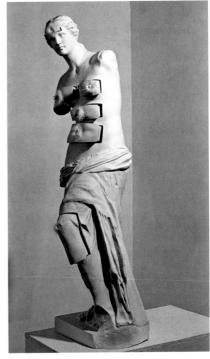

to New York in 1934. "Surrealism was already being considered as before and after Dalí ... the soft, the deliquescent ornamentation, the ecstatic sculpture of Bernini, the gluey, the biological, putrefaction – was Dalínian. The strange medieval object, of unknown use, was Dalínian. A bizarre anguishing glance discovered in a painting by Le Nain was Dalínian. An 'impossible' film with harpists and adulterers and orchestra conductors – this ought to please Dalí ... The bread of Paris was no longer the bread of Paris. It was my bread, Dalí's bread, Salvador's bread." And indeed, the vogue for Surrealist objects by Dalí had discredited the vogue for dreams and boring "automatic" recitals. "The Surrealist object had created a new need for reality. People ... wanted to touch the 'marvellous' with their hands With the surrealist object I thus killed elementary surrealist painting in general. Miró had said, 'I want to assassinate painting!' And he assassinated it – skillfully and slyly abetted by me, who was to give it its death-blow ... I do not think Miró quite realized that the painting that we were going to assassinate together was 'modern painting' ..."

ABOVE LEFT **Burning Giraffe**, c. 1937 Oil on wood panel, 35 x 27 cm ($13\frac{34}{4}$ x $10\frac{1}{2}$ in.) Emanuel Hoffmann Foundation, on permanent loan to the Kunstmuseum Basel

ABOVE RIGHT **Venus de Milo with Drawers**, 1936 (1964) Bronze, with plaster-like mount and fur tassels, 99 x 29.5 x 31.5 cm (39 x $11\frac{3}{4}$ x $12\frac{1}{2}$ in.) Rotterdam, Museum Boijmans Van Beuningen

Dalí returned regularly to Cape Creus to look for the "hard", the "soft", the concrete basis of dreams, and the traditional, which it was necessary to save from oblivion. It was there that he discovered "the profound sense of nature's modesty which Heraclitus referred to in his enigmatic phrase 'Nature likes to conceal herself' ... Watching the 'stirring' of the forms of those motionless rocks, I meditated on my own rocks, those of my thought." It was there, too, that thanks to the "glorious paranoiac-critical method" he abandoned himself to Sleep (c. 1937, p. 46). This sleep is a "veritable chrysalitic monster whose morphology and nostalgia are leaning on eleven principal crutches ... It is enough for one lip to find its exact support in a corner of the pillow or for the little toe to cling imperceptibly to the fold in the sheet for sleep to grip us with all its force. Then the horrible forehead protrudes heavily and supports itself on the soft column of the nose in the form of a biological 'collapsed vortex' par excellence, the same as flourishes in the volute of flesh crowning the dorsal curvature of the embryo, the vegetal volute of the fern and the stone volutes of columns, seated embryos. On the nose, the stem is the dorsal column of architecture itself. Michelangelo, that old man and authentic embryo, agrees with me. He says that the volute of sleep is grandiose, muscular, persevering, absorbed, entirely absorbed, exhausted, triumphant, heavy, light, and preserved; that is to say that Gaudí was again a thousand times right." Cape Creus also provided Dalí with the setting for Couple with their Heads Full of Clouds (1936,

Sleep, c. 1937 Oil on canvas, 51 x 78 cm (20 x 30¾ in.) Private collection

"Sleep is a veritable chrysalitic monster whose morphology and nostalgia are leaning on eleven principal crutches, equally chrysalitic, to be studied separately."

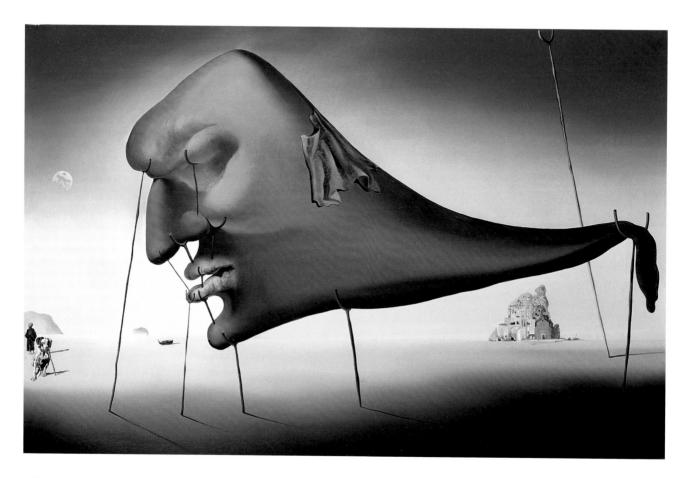

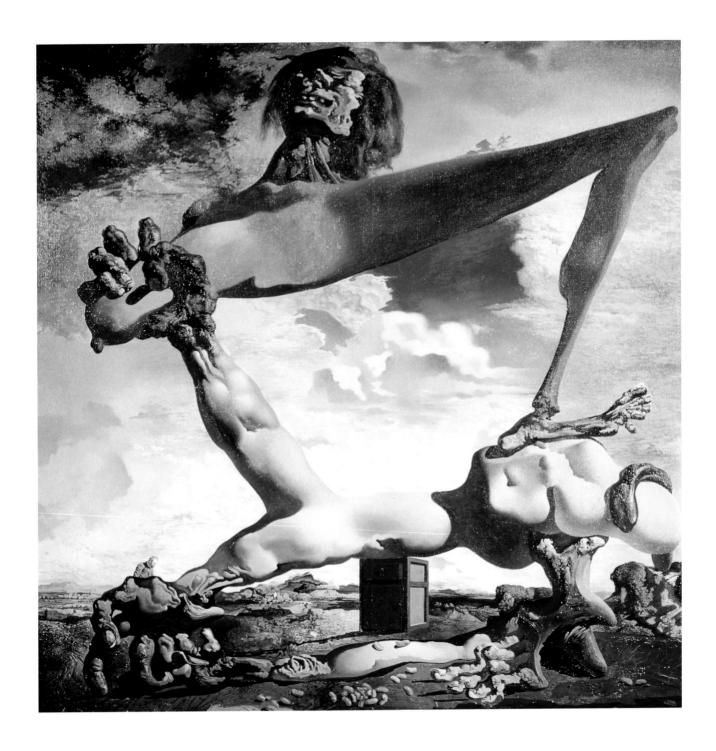

pp. 48–49), in which the silhouettes of Gala and Salvador adopt the same poses as Millet's figures in *The Angelus* (1857–59, p. 34). Inside their heads, the sky opens up over the beach at Portlligat. On the table in the foreground are the fetishes: the glass equalling the spoon-woman, the Hitlerian nurse represented by a kilo weight and, finally, Lenin represented by a bunch of black Muscatel grapes. Inside the female figure, the left-hand corner of the tablecloth conjures up an anthropomorphic silhouette holding its head in both hands, for Eros and Thanatos are one.

Soft Construction with Boiled Apricots/ Soft Construction with Boiled Beans (Premonition of Civil War), 1936 Oil on canvas, 99.9 x 100 cm (39¼ x 39¼ in.) Philadelphia Museum of Art. The Louise and Walter Arensberg Collection

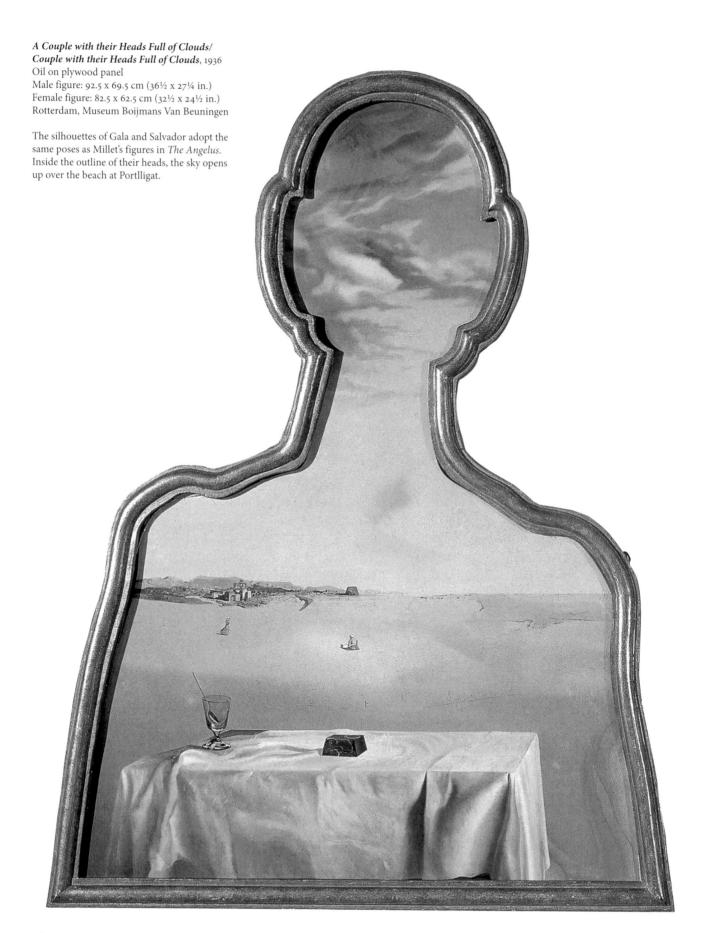

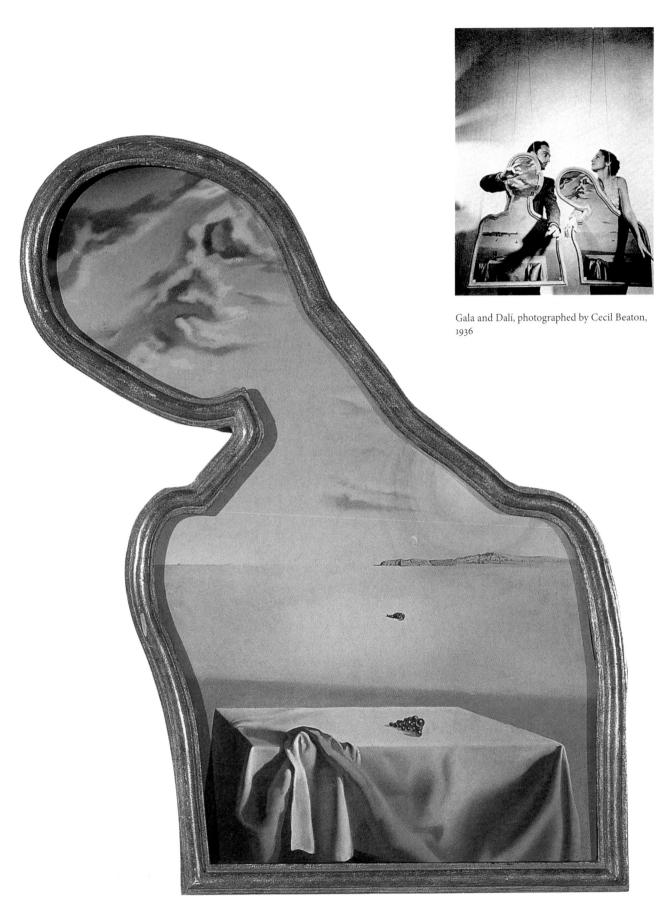

Slave Market (with apparition of the invisible bust of Voltaire), 1940

Oil on canvas, $46.2 \times 65.2 \text{ cm} \ (18\% \times 25\% \text{ in.})$ St. Petersburg, Florida, The Salvador Dalí Museum

A typical example of a double image. Dalí: "Through her patient love, Gala protects me from the ironic and swanning world of slaves. Gala in my life destroys the image of Voltaire and every possible vestige of scepticism. In painting this picture I kept reciting Joan Salvat-Papasseit's poem which ends: 'Love and war the salt of the earth."

Dalí was fully aware of this all-pervading idea: "The two motors which drive the superfine artistic mind of Salvador Dalí are first, the libido or sexual instinct, and second, the fear of death ... not a single minute of my life passes without the sublime, Catholic, apostolic, Roman spectre of death accompanying even the least of my highly subtle and capricious fantasies." Visage of the War (1940, p. 51) stares with eyes filled with human skulls. Dalí is deploying optical tricks, employing double and triple images, sometimes multiplying them to infinity. Slave Market (with apparition of the invisible bust of Voltaire) (1940, p. 50) is a characteristic example of a double image, in which Houdon's bust of Voltaire disappears to give place to a group of people. Dalí sought with this type of painting to demonstrate the physical process of human sight, whereby the image is reversed by the optic neurons. Dalí's underlying ideas, however, are quite serious. In The Secret Life he is more specific: "A period of ascetic rigour and of a quintessential violence of style was going to dominate my thinking and my tormented life, illuminated solely by the fires of faith of the Spanish Civil War and the aesthetic fires of the Renaissance – in which intelligence was one day to be reborn ... And all at once, in the middle of the cadaverous body of Spain, half devoured by the vermin and the worms of exotic and materialistic ideologies, one saw the enormous Iberian erection, like an immense cathedral filled with the white dynamite of hatred. To bury and to unbury! To unbury and to bury! To bury in order to unbury anew!

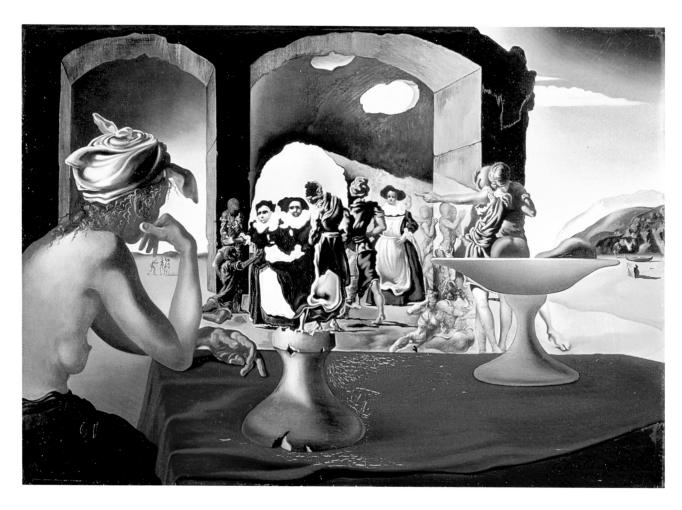

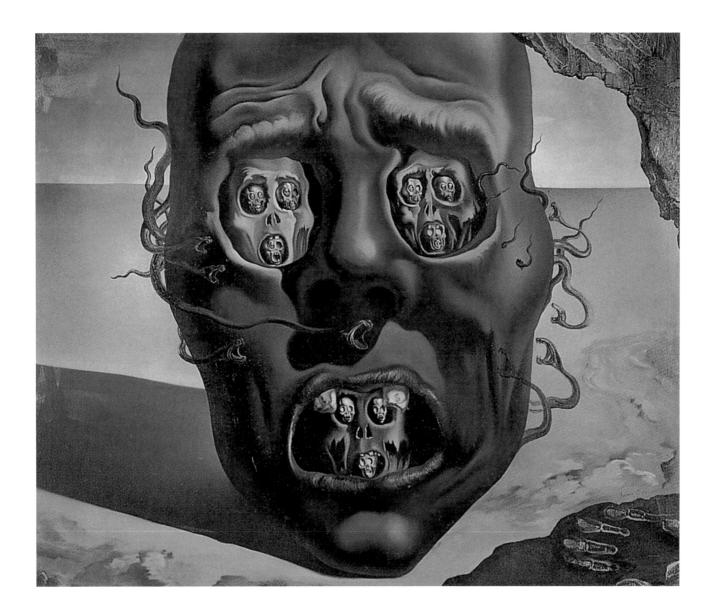

Therein lay the whole carnal desire of the civil war of that land of Spain ... And this was what we were now to witness – what the land of Spain was capable of – a planetary capacity for suffering and inflicting suffering, for burying and unburying, for killing and resuscitating. For it was going to be necessary for the jackal claws of the revolution to scratch down to the atavistic layers of tradition in order that ...one might in the end be dazzled anew by that hard light of the treasures of 'ardent death' and of putrefying and resurrected splendours that this earth of Spain held hidden in the depths of its entrails."

Visage of the War, 1940 Oil on canvas, 64 x 79 cm (25¼ x 31 in.) Rotterdam, Museum Boijmans Van Beuningen

Dalí is obsessed with death, whether it appears as the face of war or, more seductively, in the shape of naked female bodies. The props he designed for the film *Moontide* were so horrifying that they were finally rejected because the technicians refused to build them.

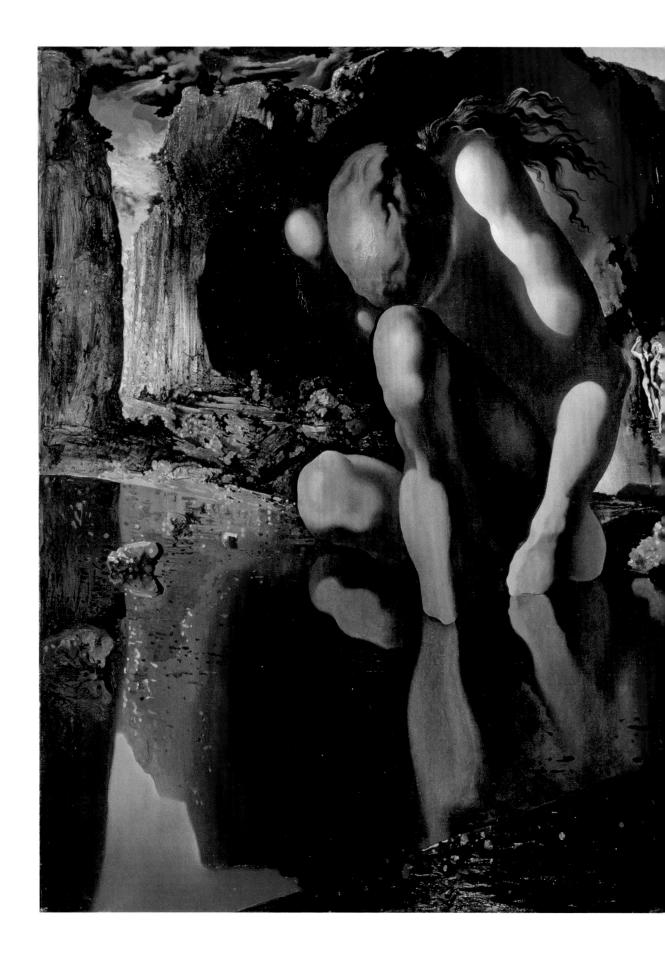

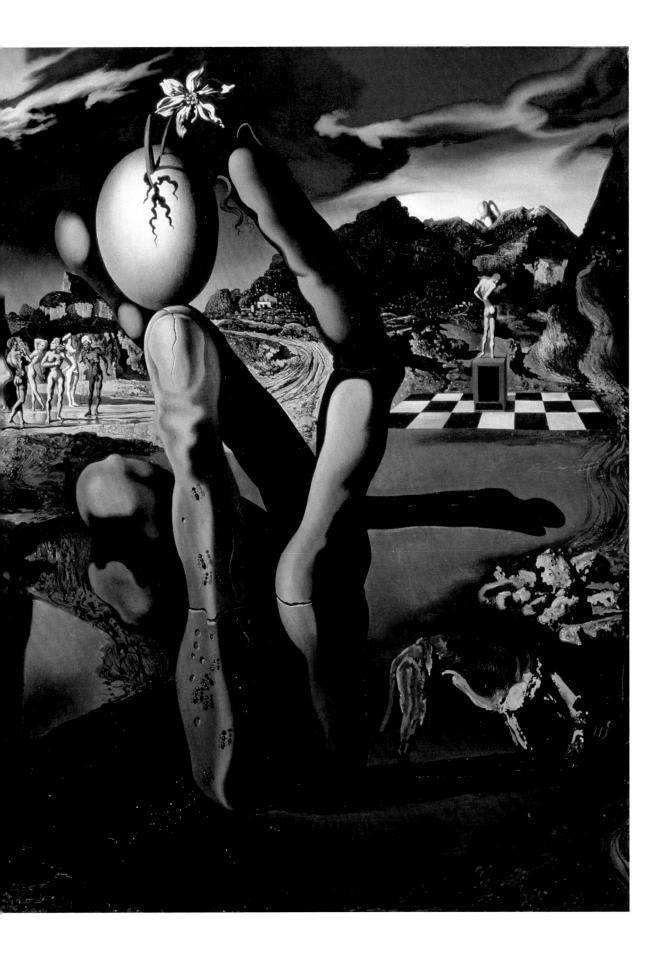

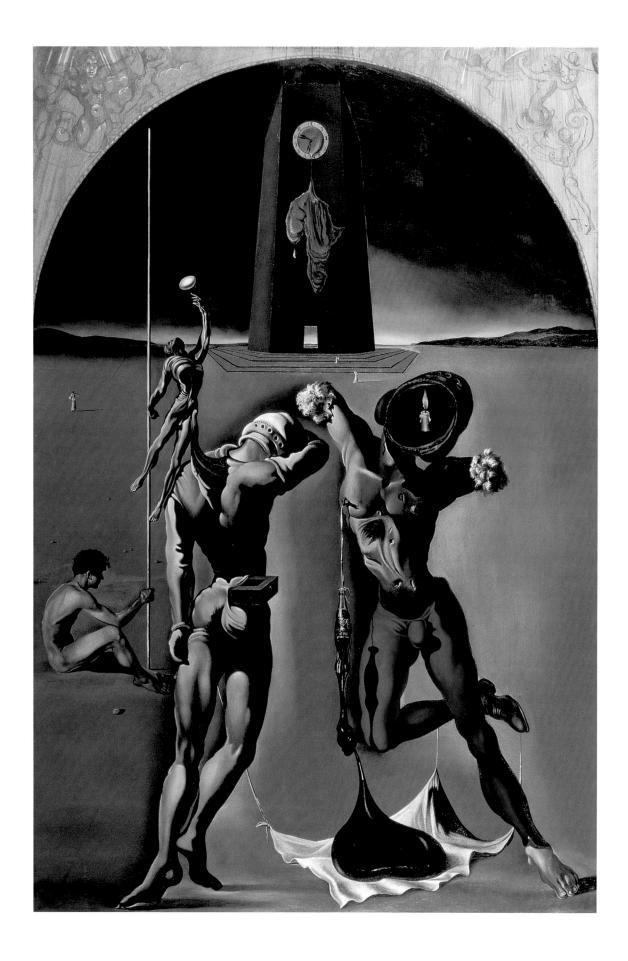

Hallucinations or Scientific Visions

"They'll eat you alive, little one ..." Gala, well-acquainted with the Surrealist group, had warned Dalí. Breton, Aragon and company were about to read him the riot act just as his own family had done. He would suffer the same constraints because, at the end of the day, "they were all Philistines". Having settled scores with his begetter, Dalí now prepared to do the same with his new father, André Breton. This was in keeping with his motto "The hero is the man who resists his father's authority and overcomes it," a quote from Freud which he later chose as the epigraph to his book.

Armed with what he called his "rather Jesuitical" sincerity, and yet "always with the thought at the back of my mind that I would soon become the leader of the Surrealists", Dalí took Surrealism "quite literally, rejecting neither the blood nor the excrement that was in their manifestos. Just as I had once endeavoured to become a perfect atheist by reading my father's books, I now became so diligent a *stud. surr.* that I was soon the only full Surrealist. So much so, that in the end I was expelled from the group because I was overly Surrealistic."

To have oneself expelled by Breton was not that difficult. The numbers who had already packed their bags were legion, and included many of the best, i.e., the most independent. Every gardener likes to prune his trees and shrubs as he pleases, after all. But Dalí, a true apostle of the movement, was not to be easily trained: "When Breton discovered my art," Dalí reports in his Diary of a Genius, "he was horrified at the scatological elements that stained it. I was surprised. The very first steps I took were taken in sh-, which, psychologically speaking, could be interpreted as an auspicious token of the gold that was fortunately to rain down on me later. I tried craftily to persuade the Surrealists that those scatological elements could bring the movement good fortune. In vain I referred to the emphatically digestive iconography found in all eras and cultures; the hen that laid the golden eggs, the intestinal delirium of Danaë, Grimm's fairy tales. But they wouldn't have it. My decision was taken at the moment. If they didn't want the sh- l was generously offering them, I would keep my treasures and gold to myself. That famous anagram André Breton thought up twenty years later, Avida Dollars, could just as well have been prophetically proclaimed then and there."

Poetry of America/The Cosmic Athletes, 1943 Oil on canvas, 116 x 79 cm (45¾ x 31 in.) Town Hall of Figueras, on permanent deposit at the Fundación Gala-Salvador Dalí, Figueras

A mixture of Catalan memories and American discoveries, but first and foremost a premonition of the victory of black over white and the decline of Africa, which is reduced to a limp and empty shell. The Coca-Cola bottle makes its first appearance in a painting, twenty years before Pop Art and Andy Warhol.

PAGES 52-53

Metamorphosis of Narcissus, 1937
Oil on canvas, 51.1 x 78.1 cm (20 x 30¾ in.)
London, Tate

This is the painting Dalí showed to Freud during their only encounter (in London in July 1938) to prove that he was one of Freud's most ardent pupils.

The Basket of Bread, 1945 Oil on plywood panel, 33 x 38 cm (13 x 14¾ in.) Figueras, Fundación Gala-Salvador Dalí

A remarkable example of the way in which Dalí succeeds in giving an epic dimension to the most mundane elements. Images of bread occupy an important place within the oeuvre of this artist, "who doesn't know what he's doing but knows what he's eating". "My aim," Dalí explained, "has been to recover the technique lost by the ancients, to arrive at the immobility of the pre-explosive object."

Gala was right: the scatological elements in Dalí's work were tolerated up to a point, but many other things were taboo. Dalí: "Once again I came up against the same prohibition as my family had imposed. I was permitted blood. A little crap was all right. But just crap was not on. Depicting genitals was approved, but no anal fantasies. They looked very askance at anuses! They liked lesbians very much indeed, but not pederasts. One could have sadism in dreams to one's heart's content, and umbrellas and sewing machines, but no religion on any account, not even if it was of a mystical nature. And to dream of a Raphael Madonna, quite simply, without apparent blasphemy, was strictly prohibited."

Dalí continually boasted of initiating dissent among the Surrealists, of racking his brains to find a way of getting them to accept an idea or an image that was completely at odds with their "taste". To this end he resorted to the "paranoiac, Mediterranean hypocrisy" which he thought himself capable of only in a state of perversity. 'They didn't like anuses! Craftily I sneaked masses of them past them, in disguise – Machiavellian anuses for preference. Whenever I made a Surrealist object in which no such apparition was to be seen, the whole object

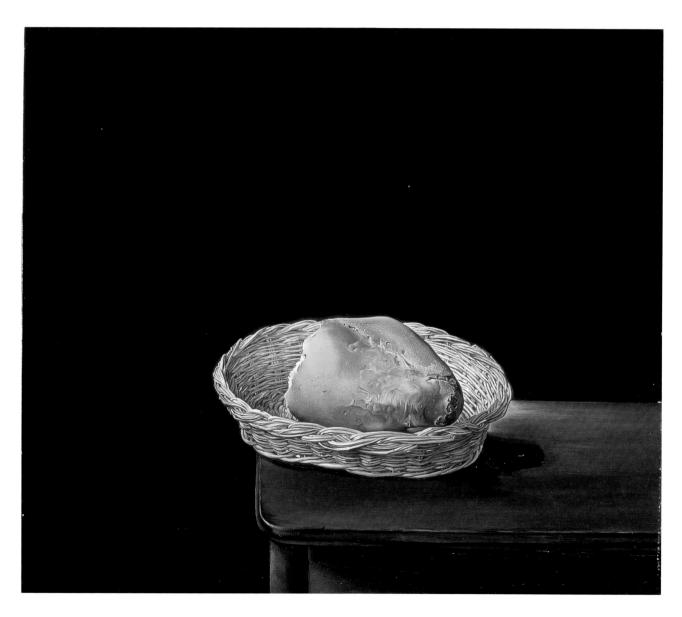

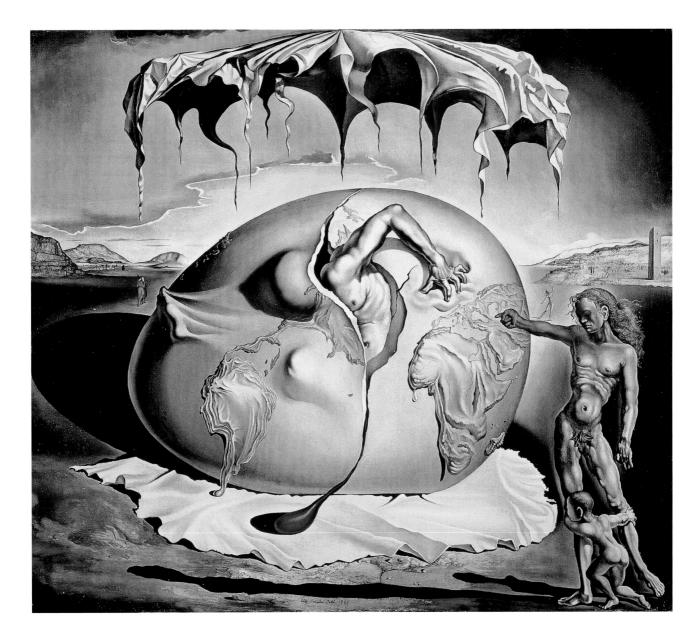

had the symbolic function of an anus. Thus I used my famous active method of paranoiac-critical analysis to counter pure, passive automatism – and the ultrareactionary, subversive technique of Meissonier to counter enthusiasm for Matisse and abstract trends. To check the cult of primitive objects I singled out the super-sophisticated objects of the modem style, which we were collecting together with Dior and which were one day to be revived as a 'new look."

This attitude was the origin of his numerous acts of provocation, such as the three-metre-long lyrical buttock supported on a crutch, with which he had wittily endowed Lenin (The Enigma of William Tell, 1933, p. 29). To his intense disappointment it did not scandalize his Surrealist friends: "But I was encouraged by this disappointment. It meant I could go still further ... and attempt the impossible. Only Aragon was outraged by my thought machine with beakers of warm milk. 'Dalí has gone far enough!' he roared angrily. 'From now on, milk is only for the children of the unemployed." With this, Dalí had scored a point; Aragon had fallen into his trap. Dalí was delighted and took advantage of the

"Geopoliticus" Child Watching the Birth of the New Man, 1943

Oil on canvas, 44.5 x 52 cm (18 x 201/2 in.) St. Petersburg, Florida,

The Salvador Dalí Museum

The intra-uterine world of the egg, handpainted in delicate colours ...

opportunity to take a swipe at his despised opponent: "Breton, thinking he saw a danger of obscurantism in the Communist-sympathizing faction, decided to expel Aragon and his adherents – Buñuel, Unic, Sadoul and others – from the Surrealist group. I considered René Crevel the only completely sincere Communist, yet he decided not to follow Aragon along what he termed 'the path of intellectual mediocrity' ... and shortly afterward committed suicide, despairing of the possibility of solving the dramatic contradictions of the ideological and intellectual problems confronting the post-war generation. Crevel was the third Surrealist who committed suicide, thus corroborating their affirmative answer to a questionnaire that had been circulated in one of its first issues by the magazine *La Révolution Surréaliste*, in which it was asked: 'Is suicide a solution?' I had answered no, supporting this negation with the affirmation of my ceaseless individual activity."

More serious, in Breton's eyes, were Dalí's political preferences. His views were startling, scandalous, and compromised the Surrealists, who failed to understand that it was quite logical for Dalí to favour regimes that upheld elites, hierarchical structures, ceremonies, public festivals that perpetuated rituals, liturgies, splendour, and armies more majestic than mighty. Monarchies are quite obviously more glamorous than democracies. The same is true, alas, of totalitarian regimes. Dalí wanted Surrealism to be surrounded by this aura of the miraculous and refused to accept the fact that the political Left is prosaic and concerned mainly with bread-and-butter questions.

Dalí loudly proclaimed that he had no interest whatsoever in politics, that he found it trivial, miserable, even threatening. On the other hand, he studied the history of religion, and of Catholicism in particular, which he increasingly came to see as the "perfect architectural structure". "Very rich people have always impressed me," he confessed to the Surrealists, "very poor people, like the fishermen of Portlligat, have likewise impressed me; average people, not at all." He regretted the fact that the Surrealists were attracting "a whole fauna of misfits and unwashed petty bourgeois ... society people every day and almost every night. Most society people were unintelligent, but their wives had jewels that were as hard as my heart, wore extraordinary perfumes, and adored the music that I detested. I remained always the Catalan peasant, naïve and cunning, with a king in my body. I was bumptious, and I could not get out of my mind the troubling image, postcard style, of a naked society woman loaded with jewels, wearing a sumptuous hat, prostrating herself at my dirty feet. This is what I most heartily desired!"

To fantasize about Hitler disguised as a woman was certainly not an innocent pastime; nor was painting a "Hitlerian wet nurse" with a swastika. Dalí's Surrealist friends could not for an instant believe that this obsession with Hitler was entirely apolitical, or that the scandalously ambiguous portrayal of a feminized Führer might contain just as much black humour as a portrait of William Tell or Lenin. Accusingly, people pointed out all the things that Hitler himself would have liked in Dalí's pictures of that period: "the swan, solitude, megalomania, Wagnerism and Hieronymus-Boschism "(Metamorphosis of Narcissus, 1937, pp. 52–53, Swans Reflecting Elephants, 1937, and later Apotheosis of Homer, c. 1945, pp. 66–67). "I was fascinated by Hitler's soft, fleshy back," Dalí defended himself, "which was always so tightly strapped into the uniform. Whenever I started to paint the leather strap that crossed from his belt to his shoulder, the softness of that Hitler flesh packed under his military tunic transported me into a sustaining and Wagnerian ecstasy that set my heart pounding, an extremely

Soft Self-Portrait with Grilled Bacon, 1941 Oil on canvas, 61 x 51 cm (24 x 20 in.) Town Hall of Figueras, on permanent deposit at the Fundación Gala-Salvador Dalí, Figueras

Dalí described this as an "anti-psychological self-portrait. Instead of painting the soul – the inside – I wanted to paint solely the outside: the envelope, 'the glove of myself.'" An edible glove, of course, albeit a little gamy, as the ants and fried bacon testify ...

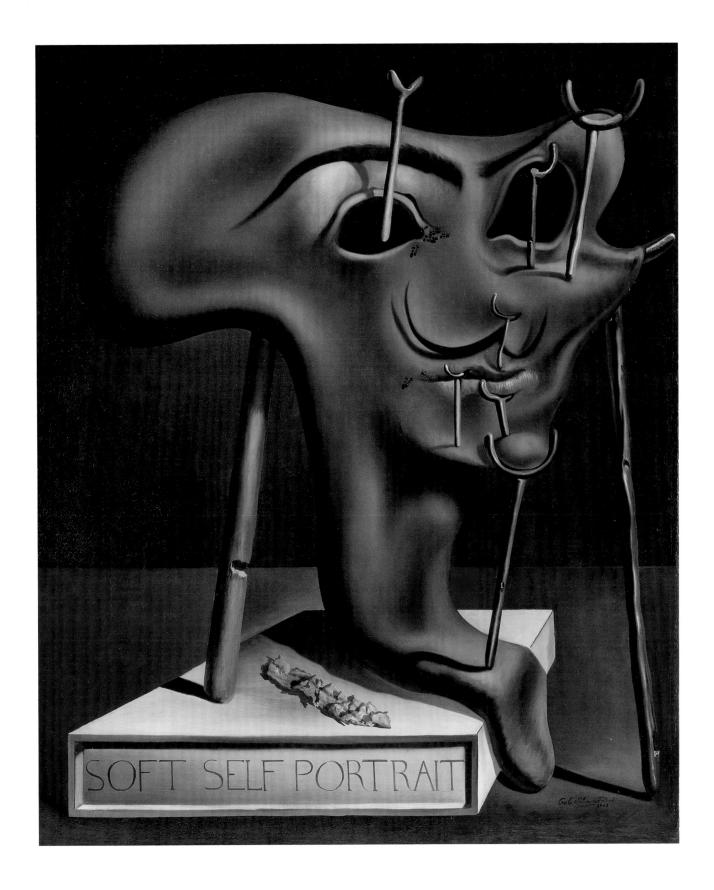

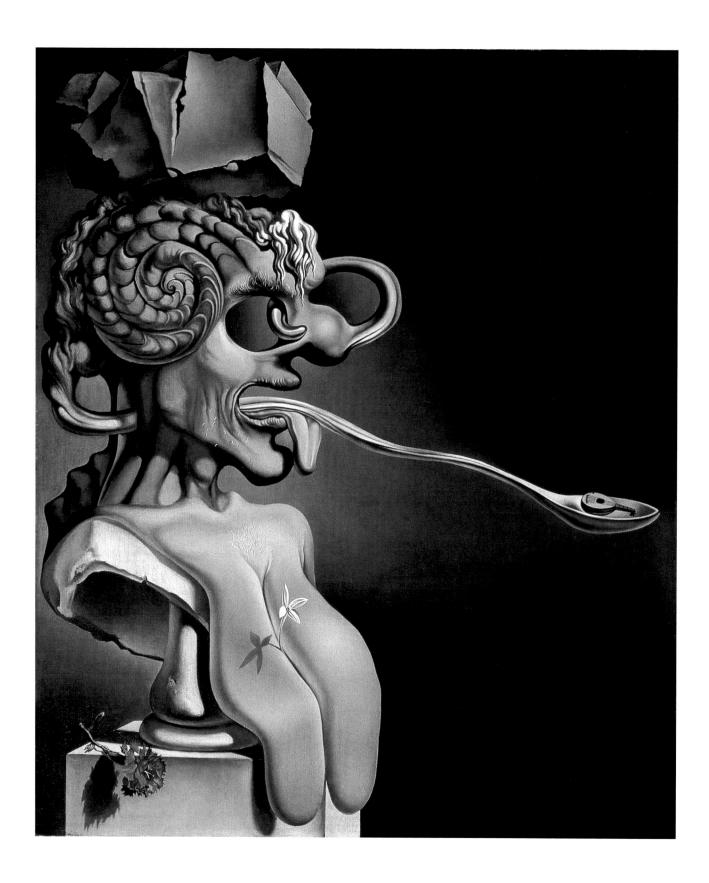

rare state of excitement that I did not even experience during the act of love ... Furthermore," he added, "I saw Hitler as a masochist, obsessed with the *idée fixe* of starting a war and losing it in heroic style. In a word, he was preparing for one of those *actes gratuits* which were then highly approved of by our group. My persistence in seeing the mystique of Hitler from a Surrealist point of view and my obstinacy in trying to endow the sadistic element in Surrealism with a religious meaning (both exacerbated by my paranoiac-critical analysis, which threatened to destroy automatism and its inherent narcissism) led to a number of wrangles and occasional rows with Breton and his friends."

In fact they had long gone beyond the stage of mere wrangles. Summoned before the group, Dalí appeared with a thermometer in his mouth, claiming that he felt ill. Supposedly suffering from a bout of influenza, he was wrapped up in pullovers and a scarf. While Breton read out the charges against him, Dalí kept checking his temperature. Then, starting his counter-attack, he began taking off his garments one by one, accompanying this striptease with a speech he had drafted in advance, defending himself and urging his friends to try and understand that his obsession with Hitler was strictly paranoiac and at heart apolitical. That it was impossible for him to be a Nazi, "because if Hitler were ever to conquer Europe, he would do away with hysterics of my kind, as had already happened in Germany, where they were treated as Entartete (degenerates). In any case, the effeminate and manifestly crackpot part I had cast Hitler in would suffice for the Nazis to damn me as an iconoclast. Similarly, my increased fanaticism, which had been heightened by Hitler chasing Freud and Einstein out of Germany, showed that Hitler interested me purely as a focus for my own mania and because he struck me as having an unequalled disaster value."

Was it his fault if he dreamt of Hitler as he dreamt of Millet's *Angelus*? When Dalí got to the passage where he announced that, "in my opinion, Hitler has four testicles and six foreskins", Breton shouted anglily: "Are you going to keep getting on our nerves much longer with your Hitler?" And Dalí, much to everyone's amusement, replied: "If I dream tonight that you and I are making love, I shall paint our best positions in the greatest of detail first thing in the morning." Breton froze and, pipe clenched tightly between his teeth, muttered furiously: "I wouldn't advise it, my friend." Once again, the confrontation is a clear example of the two men's rivalry and their struggle for power: which of them would get the better of the other?

Following this memorable exchange, Dalí was notified of his expulsion in what was almost judicial terminology: "Since Dalí had repeatedly been guilty of counter-revolutionary activity involving the celebration of Fascism under Hitler, the undersigned propose ... that he be considered a Fascist element and excluded from the Surrealist movement and opposed with all possible means." Despite his expulsion Dalí nevertheless continued to participate in all the Surrealist demonstrations and exhibitions – after all, the movement depended on the magnetic hold he had on the public, as Breton very well knew. The pope of Surrealism had to admit that, with his paranoiac-critical method, Dalí had provided Surrealism with "an instrument of the very first order". Even the dyedin-the-wool purist André Thirion had to concede that "Dalí's contribution to Surrealism was of immense importance to the life of the group and the evolution of its ideology. Those who have maintained anything to the contrary have either not been telling the truth or have understood nothing at all. Nor is it true that Dalí ceased to be a great painter in the fifties, even though it was distinctly discouraging when he turned to Catholicism ... In spite of everything, what

Portrait of Pablo Picasso in the Twenty-first Century (One of a series of portraits of Geniuses: Homer, Dali, Freud, Christopher Columbus, William Tell, etc.), 1947 Oil on canvas, 65.5 x 56 cm (26 x 22 in.) Town Hall of Figueras, on permanent deposit at the Fundación Gala-Salvador Dalí, Figueras

According to Dalí, Picasso was concerned not with beauty but with ugliness. Picasso's fanatical intellectualism is betrayed by the brain coming out of his nose and turning into a spoon that scoops everything up ...

Picasso, 1947 Charcoal Private collection

Dalí poked fun at the Communist leanings of his brilliant compatriot. He captioned the picture as follows: "Picasso is a Communist ... neither am I."

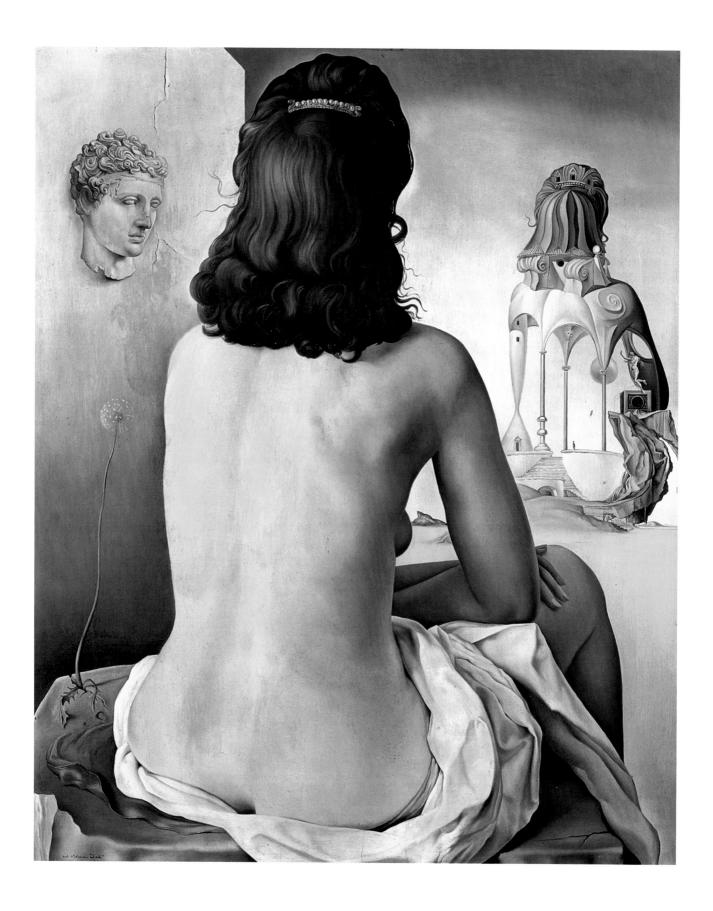

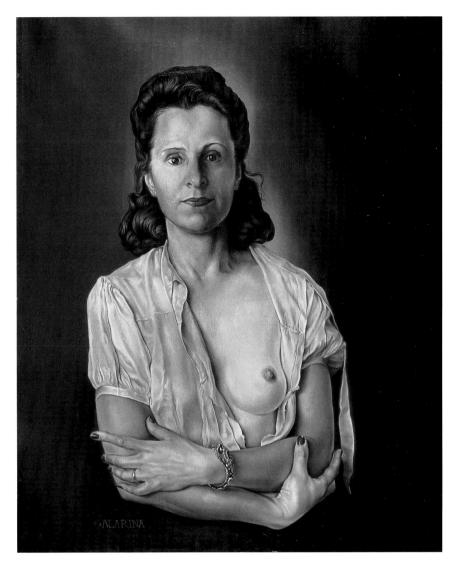

PAGE 62
My Wife, Nude, Contemplating her Own
Flesh Becoming Stairs, Three Vertebrae
of a Column, Sky and Architecture, 1945
Oil on wood panel,
61 x 52 cm (24 x 20½ in.)
New York, José Mugrabi Collection

LEFT *Galarina*, 1945 Oil on canvas, 64 x 50 cm (25¼ x 19¾ in.) Figueras, Fundación Gala-Salvador Dalí

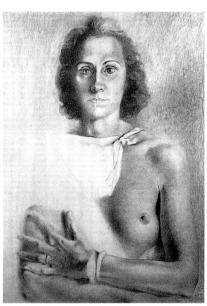

we are constantly seeing in his work is exemplary draughtsmanship, a startling inventive talent, and a sense of humour and of theatre. Surrealism owes a great deal to his pictures."

So what exactly was Dalí's so-called "paranoiac-critical method"? Dalí offered an explanation in one of his seminal essays, *The Conquest of the Irrational (La conquête de l'irrationnel*; 1935): "My whole ambition in the pictorial domain is to materialize the images of concrete irrationality with the most imperialist fury of precision ... images which provisionally are neither explicable nor reducible by the systems of logical intuition or by the rational mechanisms." He went on to stress: "Paranoiac-critical activity: spontaneous method of irrational knowledge based upon the interpretive-critical association of delirious phenomena." These phenomena already comprise the systematic structure in its entirety and "only become objective *a posteriori* by critical intervention". The infinite possibilities of the paranoiac-critical method can be born solely of the "obsessing idea", Dalí concluded with what appeared to be an about-turn but which in fact was a warning: anticipating with exceptional insight the connection between the consumer society and the atavistic need for the edible, he

Portrait of Gala, 1941 Pencil on paper, 63.9 x 49 cm (25 x 19¼ in.) Rotterdam, Museum Boijmans Van Beuningen, on loan from the New Trebizond Foundation

Raphael painted la Fornarina ... Dalí paints la Galarina. A victorious Eve, in *Galarina* she wears the domesticated serpent on her wrist. The position of her arms also makes her Dalí's "bread basket", and her naked breast resembles "the heel of a loaf". Finally, in *My Wife, Nude,* she is transformed into seethrough architecture, like an insect that has been eaten from within by ants. Through the holes in her anatomy Dalí could see the sky: "Every time I wish to attain purity, I look at the sky through the flesh ..."

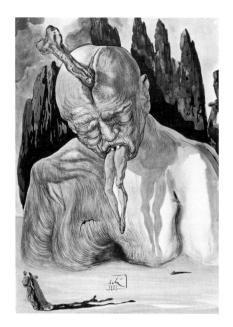

A Logician Devil - Lucifer. Illustration for Dante's *Divine Comedy*, 1951 Watercolour and pencil; dimensions unknown Private collection

"In this era of decadence in religious art which we are passing through, it is better to solicit unbelieving geniuses than believers devoid of genius." declared that these semblances of the imponderable conceal nothing less than "the very well-known, sanguinary and irrational grilled cutlet which shall eat us all". This anthropophagic "cutlet" would later be taken up by Warhol, Jasper Johns, Oldenburg, Wesselmann and others to sing the praises of the Coca-Cola bottle, Campbell's soup tins and the plastic-clad women of American Pop Art.

The Cosmic Athletes (1943, p. 54) therefore not only represents Dalí's conquest of the New World, but is also one of the avatars of his prophetic and paranoiac-critical method. It is an indissoluble mixture of idealized childhood memories and discoveries on the new continent, which was his home for the duration of the Second World War. Vestiges of the Ampurdán plain, the tower on the Pichot estate, the hills of the Cadaqués hinterland and the coast around Cape Creus are assimilated with the desert reaches of parts of North America. In portraying a new landscape, no matter how foreign, Dalí always drew on his own memories. Within this vast expanse of sand, stretching to infinity, we see the distant silhouette of a woman. In the foreground two male figures demonstrate the brutality of American football. Two players, one dressed in black, the other in white, face each other, their caps and suits reminiscent of Italian Renaissance costumes. The one in white looks like a mutilated display dummy: with an empty head and a body of stuffing, he gives birth to nothing but a Coca-Cola bottle, which has begun to putrefy and is oozing black liquid. The black figure, a new Adam, gives birth to the man of the future, who balances the ovum of the future world on the tip of his index finger.

According to Dalí, this highly moralizing painting belongs to the group of pictures anticipating great battles. Black America, triumphant and horrified, almost refuses to witness the inevitable self-destruction of its white brother. In this picture, in fact, Dalí seems to have had a premonition both of the difficulties that would arise between black and white communities after the war, and of the decline of Africa, which hangs like a limp map from the façade of the mausoleum tower, with the clock seemingly marking the fateful hour. For Dalí, the Coca-Cola bottle also held a premonition: as he pointed out to Robert Descharnes, he paints it here with photographic precision some twenty years in advance of Andy Warhol. Before discovering the Catalan artist's painting, the American Pop artists had long been persuaded that they were the first to take an interest in this genre of banal and anonymous objects.

The insights Dalí gained from his various visits to the United States, and the results of his reflections on the dynamism of American life, represented by the two football players, are summed up in the following statement: "What the American people love best is, first of all, blood – you have all seen the great American films, especially the historical ones. There are always scenes where the hero is beaten up in the most sadistic manner and where one witnesses veritable orgies of blood! Secondly, the soft watches. Why? Because Americans are constantly checking their watches. They are always in a hurry, a terrible hurry, and their watches are terribly stiff, tough, and mechanical. So the day that Dalí painted his first soft watch brought instant success! For at long last, this terrible object, which marked the inescapable sequences of their lives every minute of the day and reminded them of their terrible business, had all of a sudden grown as soft as a Camembert cheese at its best, when it gets runny. But the greatest passion of the American people is to watch their children being destroyed. Why? Because according to the most renowned American psychologists, the slaughter of the innocents is people's favourite subject, something that is buried in the very depths of their subconscious. It is because the children

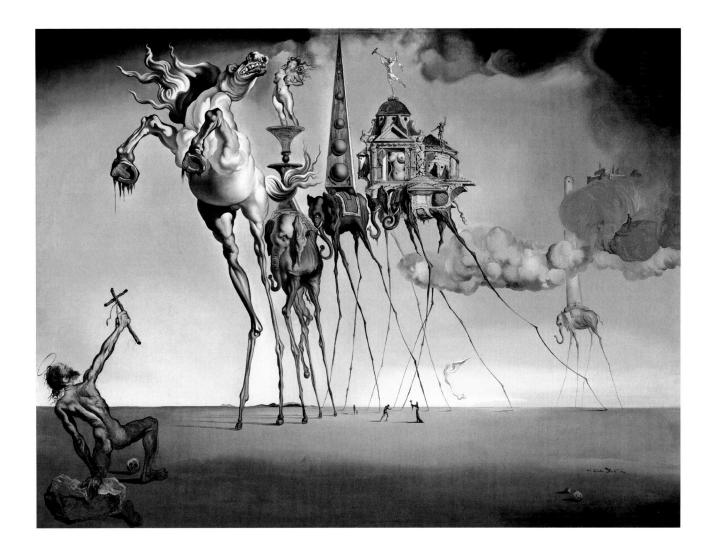

are constantly getting on their nerves, so much so, that their libido is turned inside out until it completely fills the cosmic surfaces of their dreams. If Americans love orgies of blood, and if they love the slaughter of the innocents, and the soft watches that run like a true French Camembert when it is ripe, it is because, of all the things in the world, what they love best are the 'dots': points of information that symbolize the discontinuity of all matter. This is why all of today's Pop Art consists entirely of such 'dots' of information."

As a result of Dalí's paranoiac-critical method, all his works of this period display the influence of modern metaphysics and scientific discoveries, trends which he followed closely. It was a phase of "hallucinations" and "scientific visions", such as *Dalí in an Egg* (1942), which Philippe Halsman translated into a photograph under Dalí's direction, and "*Geopoliticus*" *Child* (1943, p. 57), which is the "hand-painted" version of the same. *Soft Self-Portrait with Grilled Bacon* (1941, p. 59) was later echoed by *Portrait of Pablo Picasso* (1947, p. 60). Dalí described his *Soft Self-Portrait* as an "anti-psychological self-portrait". "Instead of painting the soul – the inside – I wanted to paint solely the outside: the envelope, 'the glove of myself'. This glove of myself is edible, and even a little gamy; this is why ants are shown, together with a strip of bacon. I am the most generous of painters, since I am constantly offering myself up to be eaten,

The Temptation of St. Anthony, 1946 Oil on canvas, 89.5 x 119.5 cm (35¼ x 47 in.) Brussels, Musées Royaux des Beaux-Arts de Belgique

Dalí is about to leave the earth in order to reach the heavenly spheres. The dimension mediating between heaven and earth is emhodied in the elephants with their spindly legs. They introduce the theme of levitation that was to be fully developed soon after in his "mystical-corpuscular" paintings.

PAGES 66–67

Apotheosis of Homer
(Diurnal Dream of Gala), c. 1945
Oil on canvas, 63.7 x 116.7 cm (25¼ x 46 in.)

Munich, Bayerische Staatsgemäldesammlungen,
Pinakothek der Moderne

Dalí: "This is the triumph of all that is impossible to express except by an ultra-concrete image." This was a little too "Wagnerian" for the Surrealists ...

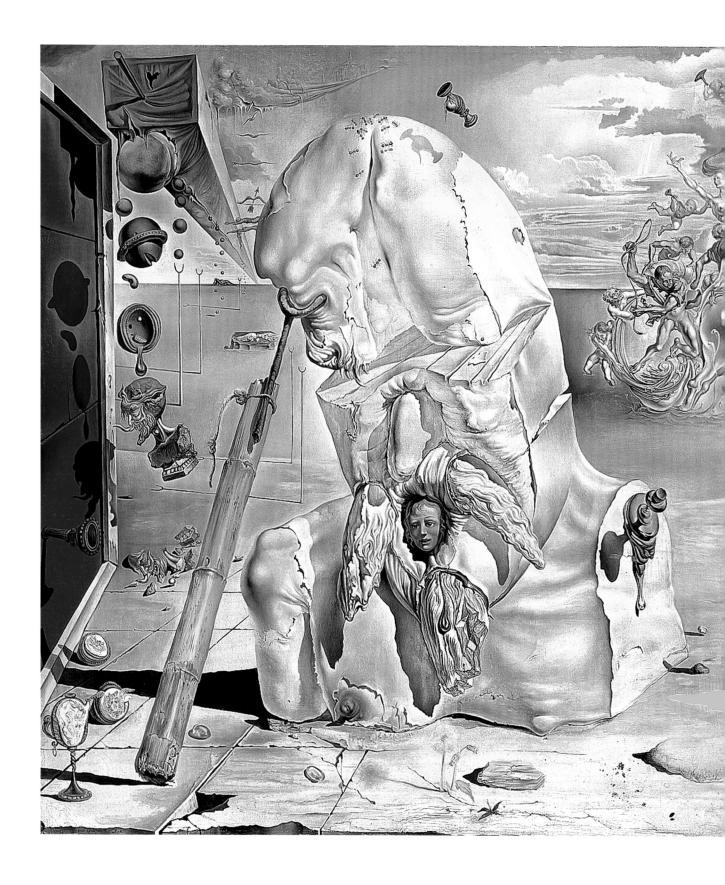

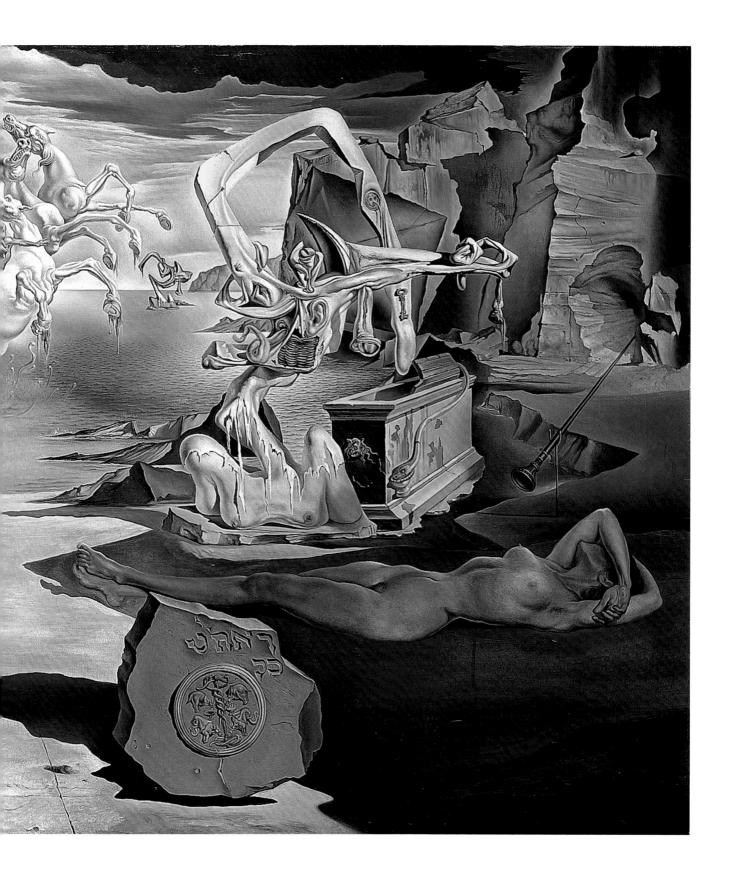

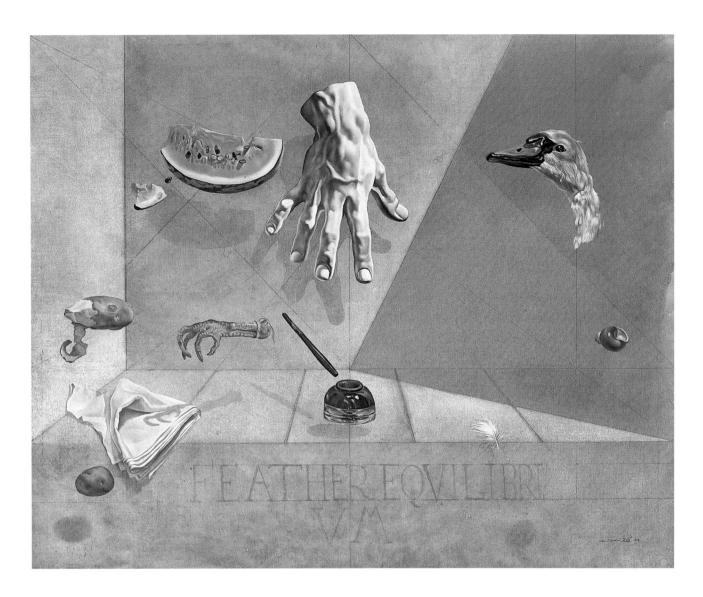

Intra-Atomic Equilibrium of a Swan's Feather, 1947 Oil on canvas, 78 x 97 cm (30¾ x 38¼ in.)

Oil on canvas, 78 x 97 cm (30¾ x 38¼ in.) Figueras, Fundación Gala-Salvador Dalí. Dalí bequest

Dematerialization near the Nose of Nero, 1947 Oil on canvas, 76.5 x 46 cm (30 x 18 in.) Figueras, Fundación Gala-Salvador Dalí. Dalí bequest

Dalí is entering his period of mystical "scientific visions", a period in which "fast-moving" still lifes and architectural compositions both refer back to artistic tradition and at the same time testify to the existence of the atom and the intra-atomic equilibrium discovered by science.

and I thus succulently nourish our time." In a way, did not Christ do the same? Dalí's Portrait of Pablo Picasso could equally well be entitled "Official Paranoiac Portrait of Pablo Picasso", since it assembles a collection of folkloric elements representing, in anecdotal form, Picasso's origins. Dalí paid tribute to his compatriot's fame by placing the bust on a pedestal, the symbol of public recognition; the breasts represent the (vital) nourishing aspect of Picasso, who carries the heavy rock of his (catastrophic) responsibility for modern painting on his head. The bust itself arises out of the combination of a goat's hoof and the headdress of a Graeco-Iberian sculpture, The Lady with the Unicorn, recalling Picasso's Andalusian and Malagueñan roots. The addition of a carnation, jasmine blossom and guitar completes the evocation of Iberian folklore. Shortly after Picasso's death, Dalí offered the following comment on this most famous of all gypsies: "I believe that the magic in Picasso's work is of a romantic nature, that is to say, it relies on overturning things, whereas mine can only be achieved by heaping up tradition. The difference between Picasso and myself is total; because he is concerned not with beauty but with ugliness, and I, increasingly with beauty; but in the extreme case of geniuses such as Picasso and me, ugly beauty and beautiful beauty may be of an angelic type."

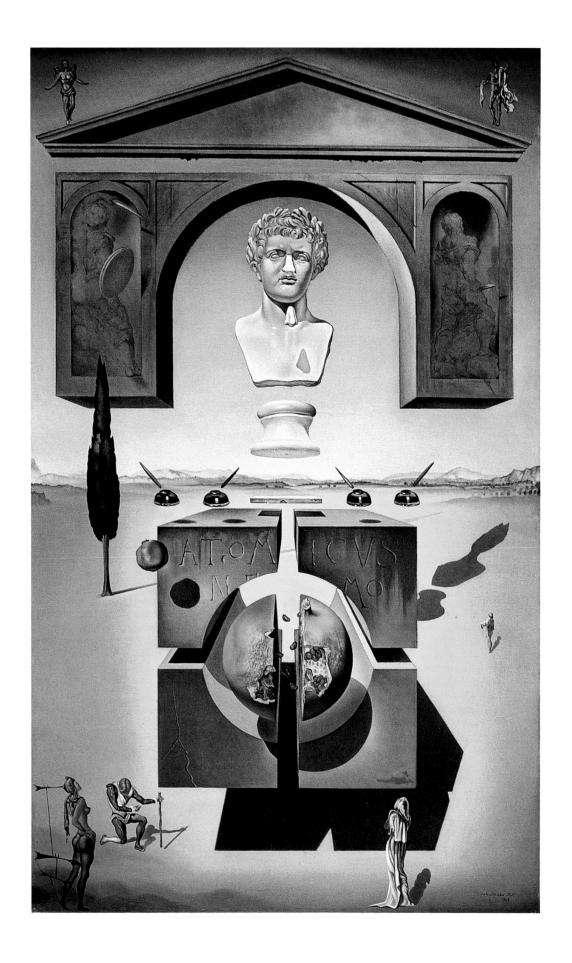

Leda Atomica, 1949 Oil on canvas, 61 x 46 cm (24 x 18 in.) Figueras, Fundación Gala-Salvador Dalí

Dalí continues the earthly saga of the Salvador—Gala couple thirsting after the absolute: "Leda Atomica is the key painting of our lives. Everything in it is suspended in space without anything touching anything. The sea itself is suspended a little distance away from the earth."

Gala Placidia/Galatea of the Spheres, 1952 Oil on canvas, 65 x 54 cm (25½ x 21¼ in.) Figueras, Fundación Gala-Salvador Dalí

To Dalí, this was the "paroxysm of joy", an "anarchic monarchy", "the unity of the universe..." Whatever the case, it is a technical tour de force which reaches a pinnacle of purity and delirious ecstasy on the mystical plane. As with Mozart, one seems to hear the "music of the spheres to which the sirens are dancing".

Nuclear Cross, 1952 Oil on canvas, 78 x 58 cm (30½ x 22¾ in.) Private collection

Bread is no longer simply an edible delirium; it has become the Eucharist and the focal point of Dalí's religious compositions. Dalí explained: "All the geological merits of Portlligat are represented in the 'Gala Madonna' picture. As in the case of the wet nurse from whose back a bedside table has been extracted – she is now transformed into a tabernacle of living flesh that opens up a view of the heavens and contains the body of Jesus. Another tabernacle is cut open in his chest to reveal the divine bread."

The group of paintings indebted to the paranoiac-critical method also includes *Dream Caused by the Flight of a Bee around a Pomegranate One Second before Awakening* (c. 1944, p. 4). Its title is almost self-explanatory: "For the first time, Freud's discovery that a typical narrative dream is prompted by something that wakes us was illustrated in a picture. If a bar falls on a sleeper's neck, it both wakes him and prompts a long dream that ends with the falling of the guillotine; similarly, the buzzing of the bee in the painting prompts the bayonet prick that wakens Gala. The burst pomegranate gives birth to the entirety of biological creation. Bernini's elephant in the background bears an obelisk with the papal insignia."

A propos *My Wife, Nude, Contemplating her Own Flesh Becoming Stairs, Three Vertebrae of a Column, Sky and Architecture* (1945, p. 62), Dalí similarly recounted: "When I was five years old, I saw an insect that had been eaten by ants and of which nothing remained except the shell. Through the holes in its

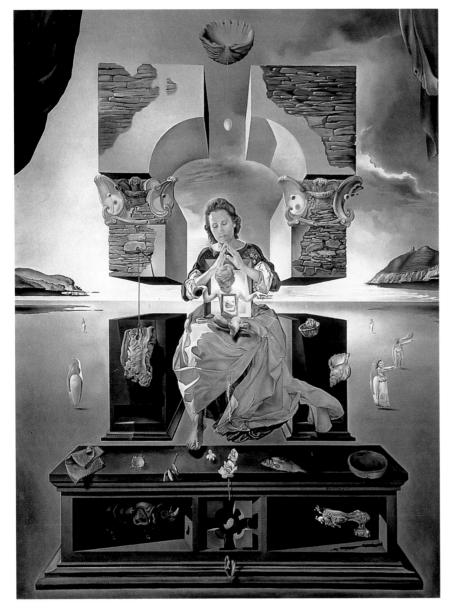

anatomy one could see the sky. Every time I wish to attain purity, I look at the sky through the flesh."

Gala, omnipresent in Dalí's oeuvre, was "the most extraordinary being one could possibly encounter, the superstar who should under no circumstances be compared with Callas or Greta Garbo; because they can be encountered fairly often, whereas Gala is the invisible, anti-exhibitionist being par excellence. With Salvador Dalí you have two heads of state, one of them is my wife, Gala, the other is Salvador Dalí. Salvador Dalí and Gala are the only two beings capable of mathematically restraining or stimulating my divine madness." Dalí named one of his paintings of Gala *Galarina* (1945, p. 63) because "Gala is to me what la Fornarina was to Raphael. And again, wholly unpremeditated, bread comes into the picture. A strict and shrewd analysis brings to light the resemblance of Gala's crossed arms to the rim of a bread basket, her breasts seemingly forming the heel of a loaf of bread. I had already painted Gala with

ABOVE LEFT *The Madonna of Portlligat*, *c.* 1950 Oil on canvas, 275.3 x 209.8 cm (108½ x 82¾ in.)
Fukuoka Art Museum

ABOVE RIGHT
Study for the head of *The Madonna of Portlligat*, 1950
Sanguine and ink on paper,
49 x 31 cm (19¼ x 21¼ in.)
St. Petersburg, Florida,
The Salvador Dalí Museum

The Ascension of St. Cecilia, 1955 Oil on canvas, 81 x 66 cm (31¾ x 26 in.) Figueras, Fundación Gala-Salvador Dalí, Gift of Dalí to the Spanish state

two lamb chops balanced on her shoulder, thereby expressing my desire to devour her. That was the time when raw meat played an important role in my imagination. Today, now that Gala has risen high in the heraldic hierarchy of my nobility, she has become my bread basket."

For once, Dalí's descliption of his work was humble: "Heaven is what I have been seeking all along and through the density of confused and demoniac flesh of my life – heaven! Alas for him who has not yet understood that! The first time I saw a woman's depilated armpit I was seeking heaven. When with my crutch I stirred the putrefied and worm-eaten mass of my dead hedgehog, it was heaven I was seeking ... And what is heaven? Gala, you are reality! Heaven is to be found, neither above nor below, neither to the right nor to the left, heaven is to be found exactly in the centre of the bosom of the man who has faith. P.S. At this moment I do not yet have faith, and I fear I shall die without heaven."

Despite being deeply engrossed in such metaphysical reflections, Dalí nevertheless continued to make a lot of money. For him, American vitality was highly nourishing – the perfect diet, so to speak. He designed jewellery and apart-

Exploding Raphaelesque Head, 1951 Oil on canvas, 43.2 x 33.1 cm (17 x 13 in.) Edinburgh, Scottish National Gallery

Dalí transcends the limits of knowledge: "More powerful than cyclotrons and cybernetic calculators, I can penetrate to the mysteries of the real in a moment ... Mine the ecstasy! ... Mine, St. Teresa of Avila! ... By reviving Spanish mysticism, I, Dalí, shall use my work to demonstrate the unity of the universe, by showing the spirituality of all substance. "

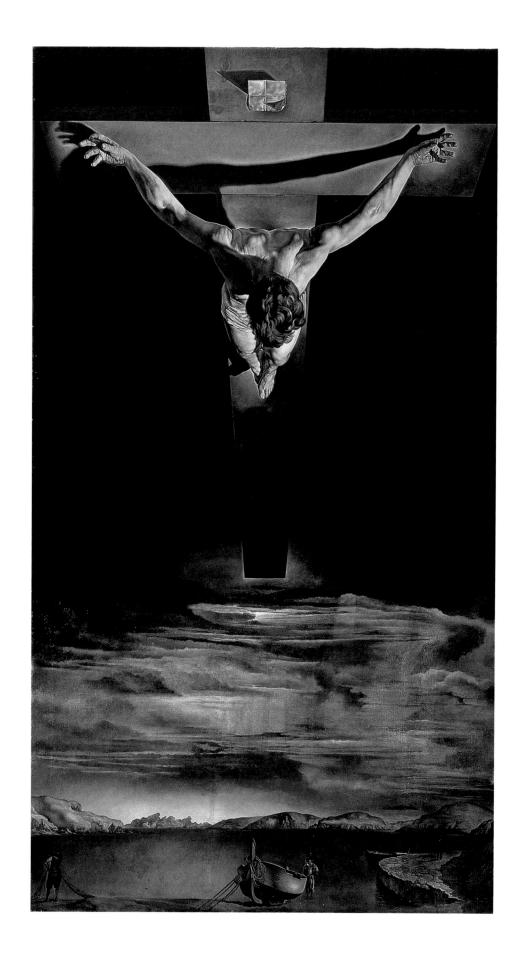

ments and decorated shop fronts for the big department stores. He worked for leading magazines such as Vogue and Harper's Bazaar, designed and created ballet sets, published, illustrated, took part in the production of films - and on the whole spoke more about the conquest of reality than the conquest of the irrational. Art News magazine commented maliciously: "The possibility cannot be ruled out that Dalí will be giving more attention to the conscious realm from now on than to the unconscious. If this does indeed prove the case, nothing need prevent him from becoming the greatest academic painter of the twentieth century." However, there was no one more aware of the changes going on within him than Dalí himself: "The two most subversive things that can happen to an ex-Surrealist are, firstly, to become mystical, and secondly, to be able to draw. I was blessed with both of these kinds of (creative) strength simultaneously. Catalonia has produced three great geniuses: Raymond de Sebonde, author of the Théologie naturelle; Gaudí, the creator of Mediterranean Gothic; and Salvador Dalí, inventor of the new paranoiac-critical mysticism and, as his Christian name suggests, the saviour of modern painting. The deep crisis of Dalínian mysticism basically derives from progress in certain scientific fields in our age; especially from the metaphysical spirituality of the substantiality of quantum physics and on the level of less substantial delusions - the most disgracefully super-gelatinous ruptures and their co-efficients of monarchic viscosity in the whole of general morphology ..."

Dalí gave the following detailed account of his conversion to mysticism: "The explosion of the atom bomb on 6 August 1945 sent a seismic shock through me. Since then, the atom has been central to my thinking. Many of the scenes I have painted in this period express the immense fear that took hold of me when I heard of the explosion of the bomb. I used my paranoiac-critical method to analyze the world. I want to perceive and understand the hidden powers and laws of things, in order to have them in my power. A brilliant inspiration shows me that I have an unusual weapon at my disposal to help me penetrate to the core of reality: mysticism - that is to say, the profound intuitive understanding of what is, direct communication with the all, absolute vision by the grace of truth, by the grace of God. More powerful than cyclotrons and cybernetic calculators, I can penetrate to the mysteries of the real in a moment ... Mine the ecstasy! I cry. The ecstasy of God and Man. Mine the perfection, the beauty, that I might gaze into its eyes! Death to academicism, to the bureaucratic rules of art, to decorative plagiarism, to the witless incoherence of African art! Mine, St. Teresa of Avila! ... In this state of intense prophecy it became clear to me that the means of pictorial expression achieved their greatest perfection and effectiveness in the Renaissance, and that the decadence of modern painting was a consequence of scepticism and lack of faith, the result of mechanistic materialism. By reviving Spanish mysticism, I, Dalí, shall use my work to demonstrate the unity of the universe, by showing the spirituality of all substance."

This avowal of mysticism was the logical conclusion of his past experience. From that time on and until the end of his life, Dalí applied mystical principles to his work, taking his avowal quite literally. And irrespective of what some people have said about them, there are a number of masterpieces among the paintings he was to create in the years ahead.

With *The Temptation of St. Anthony* (1946, p. 65), Dalí – who, despite calling himself an "ex-Surrealist", remained more of a Surrealist than ever – marked the introduction into his universe of a mediating dimension between heaven and earth, embodied in the elephants with their spindly legs. They anticipate the

Drawing of "Christ on the Cross", executed by St. John of the Cross (1542–1591) Sanguine on paper, 75.7 x 101.7 cm (29¾ x 40 in.); St. Petersburg, Florida, The Salvador Dalí Museum

ABOVE LEFT
Diego Rodriguez de Silva y Velázquez
Study for *The Surrender of Breda*, *c*. 1635
Charcoal on paper, 26.2 x 16.8 cm
(10¼ x 6½ in.)
Madrid, Biblioteca Nacional

ABOVE RIGHT
Louis Le Nain *Peasants in Front of their House* (detail), *c.* 1642
Oil on canvas
San Francisco, Palace of the Legion of Honor

The Christ/Christ of Saint John of the Cross, c. 1951 Oil on canvas, 204.8 x 115.9 cm (80½ x 45½ in.) Glasgow, Kelvingrove Art Gallery and Museum

In a "cosmic dream" Dalí saw that the "nucleus of the atom", the unity of the universe, is in fact Christ himself. He found this confirmed by a drawing by St. John of the Cross, which Dalí schematizes as a triangle inside a circle. The inevitable allusions to tradition here take the form of a homage to Velázquez and Le Nain.

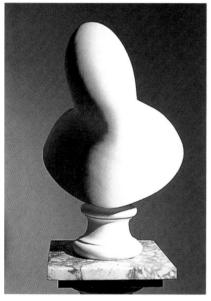

TOP Jan Vermeer *The Lacemaker*, c. 1669–70 Oil on canvas, 24.5 x 21 cm (9½ x 8¼ in.) Paris, Musée du Louvre

ABOVE

Rhinocerotic Bust of Vermeer's "Lacemaker" (original state), 1955
Patinated plaster, 50.5 x 35.4 x 38.5 cm (19¾ x 14 x 15 in.), private collection

PAGE 79

Young Virgin Auto-Sodomized by Her Own Chastity, 1954

Oil on canvas, 40 x 30 cm (15¾ x 11¾ in.) Private collection

Fearing impotence, Dalí uses the mythical rhinoceros horn (the legendary unicorn) to "penetrate" Vermeer's masterpiece *The Lacemaker*, and "split her open like a watermelon". The horn had already served the same purpose in *Exploding Raphaelesque Head*.

theme of levitation, the neutralization of gravity, that was to be fully developed soon after in his "mystical-corpuscular" paintings. Temptation appears to Saint Anthony in a parade of different forms: at the front, a rearing horse symbolizing both power and sensual pleasures, followed by a group of elephants. The first carries the Cup of Desire topped by a naked woman seized with lust, the next an obelisk inspired by the Roman sculptor Bernini. Elephants bearing Palladian-style architecture and a phallic tower make up the rear. The distant clouds reveal glimpses of El Escorial, which represents spiritual and temporal order. Dalí would henceforth devote himself to this threefold synthesis of classical painting, the atomic age and intense spiritualism.

"My ideas were ingenious and abundant. I decided to turn my attention to the pictorial solution of quantum theory, and invented quantum realism in order to master gravity ... I painted Leda Atomica (1949, p. 70), a celebration of Gala, the goddess of my metaphysics, and succeeded in creating 'floating space'; and then Dalí at the Age of Six, When He Thought He Was a Girl Lifting with Extreme Precaution the Skin of the Sea to Observe a Dog Sleeping in the Shade of the Water - a picture in which the personae and objects seem like foreign bodies in space. I visually dematerialized matter; then I spiritualized it in order to be able to create energy. The object is a living being, thanks to the energy that it contains and radiates, thanks to the density of the matter it consists of. Every one of my subjects is also a mineral, with its place in the pulse beat of the world and a living piece of uranium ... I maintain with full conviction that heaven is located in the breast of the faithful. My mysticism is not only religious, but also nuclear and hallucinogenic. I discovered the selfsame truth in gold, in painting soft watches, or in my visions of the railway station at Perpignan (cf. p. 90). I believe in magic and in my fate."

The first pictures in this new series were the two versions of *The Madonna of Portlligat*, of which Dalí presented the smaller to Pope Pius XII on 23 November 1949. Undoubtedly the best-known, however, is *Christ of Saint John of the Cross* (c. 1951, p. 76), in which the figure of Christ dominates the bay of Portlligat. The composition was inspired by a drawing executed by St. John of the Cross while in a state of ecstasy, which is now housed in the Convent of the Incarnation at Avila. The figure behind the boat is taken from an oil painting by Le Nain (*Peasants in Front of their House*, c. 1642, p.77), and the figure on the far left from a charcoal study by Velázquez for *The Surrender of Breda* (c. 1635, p. 77).

Dalí explained the work as follows: "It began in 1950 with a cosmic dream I had, in which I saw the picture in colour. In my dream it represented the nucleus of the atom. The nucleus later acquired a metaphysical meaning: I see the unity of the universe in it – Christ! Secondly, thanks to Father Bruno, a Carmelite monk, I saw the figure of Christ drawn by St. John of the Cross; I devised a geometrical construct comprising a triangle and a circle, the aesthetic sum total of all my previous experience, and put my Christ inside the triangle."

None of this prevented Dalí from reverting to the profane from time to time. Erotic delirium added depth to his mysticism: "Eroticism is the royal road of the spirit of God." He also settled an old, secret score with his sister, painting her as the *Young Virgin Auto-Sodomized by Her Own Chastity* (1954, p. 79). Drive Dalí out, and he simply comes galloping back: "Painting," he declared, "like love, goes in at the eyes and flows out by the hairs of the brush. My erotic delirium compels me to take my sodomitic tendencies to the heights of paroxysm."

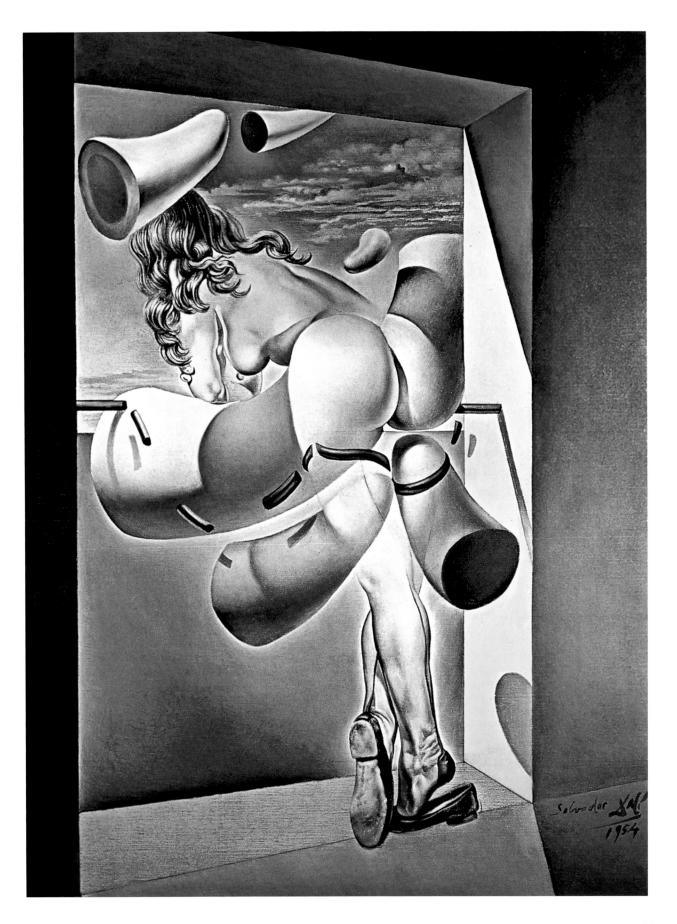

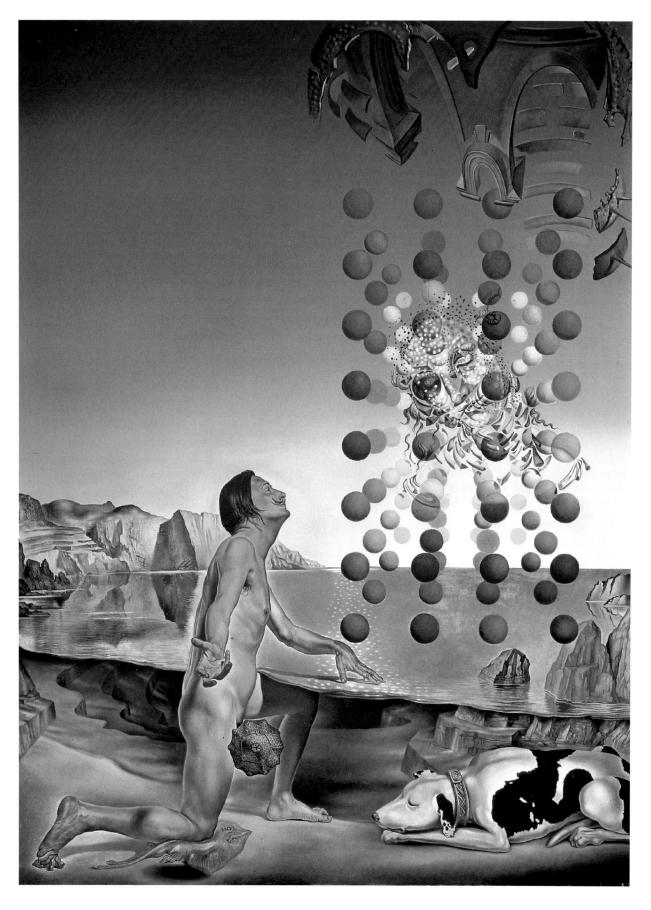

Dalí had painted a portrait of his sister during his earlier scatological period, a rear view which emphasized the girl's buttocks (Girl at a Window, 1925, p. 12). To make sure that the point was not lost on anybody – and eager to scandalize the Surrealists - he subtitled it "Portrait of my Sister, her Anus Red with Bloody Shit". Twenty years later his memory rather beautified Ana María Dalí, who was a short, plump girl; inspired by a photograph in a pornographic magazine, he completely transformed her. Continuity of this kind once again illustrates the mental processes behind Dalí's work: a memory whose traces are still fresh in his mind sets in motion a whole set of wheels, in which analytical intelligence is applied to violent erotic fantasies. The 1954 picture thus becomes a veritable lyrical feast in which the firmness of Ana María's glamourized behind reveals an imaginative kinship with a rhinoceros horn, which had already served to deflower Vermeer's Lacemaker (c. 1670-71, p. 78) during the course of a "happening". This rhinoceros horn provides Salvador Dalí with the illusion of a fantastic erection that finally allows him to live out his fantasy: to penetrate his sister's "anus, red with bloody shit". Revenge is a Catalan dish, eaten cold! Expressing himself through the rhinoceros horn permitted Dalí to respect the demands of chastity, which by then had become to him "an essential precondition of the spiritual life".

Pictures such as Discovery of America by Christopher Columbus (1958, p. 84), Tuna Fishing (c. 1966-67, p. 86) and his Hallucinogenic Toreador (1969, p. 87) are typical examples of the gigantism that was predominant in Dalí's late work. These paintings, usually teeming with Dionysian figures, are a form of testament, the fruits of forty years of passionate pictorial research. They combine all the styles in which the artist had worked: Surrealism, "quintessential pompierism", Pointillism, action painting, Tachisme, geometric abstraction, Pop Art, Op Art and psychedelic art. In pictures such as Dalí from the Back, Painting Gala from the Back, Eternalized by Six Virtual Corneas Provisionally Reflected in Six Real Mirrors (1972-73, p. 91), Dalí's Hand Drawing Back the Golden Fleece in the Form of a Cloud to Show Gala the Dawn, Completely Nude, Very, Very Far Away Behind the Sun (1977, p. 89) and Dalí Lifting the Skin of the Mediterranean Sea to Show Gala the Birth of Venus (1977, p. 89), Dalí used stereoscopy to paint his last visual poems and pay a final homage to his earthly "double", producing "metaphysical photorealism" literally along the way: "Binocular vision is the Trinity of transcendent physical perception. The Father, the right eye, the Son, the left eye, and the Holy Ghost, the brain, the miracle of the tongue of fire, the luminous, virtual image having become incorruptible, pure spirit, Holy Ghost" (Ten Recipes for Immortality (Dix recettes d'immortalité), 1973).

"I'm not the clown!" Dalí defended himself, "but in its naïvety, this monstrously cynical society does not see who is simply putting on a serious act the better to hide his madness. I cannot say it often enough: I am not mad. My clearsightedness has acquired such sharpness and concentration that, in the whole of the century, there has been no more heroic or more astounding personality than me, and apart from Nietzsche (who finished by going mad, though) my equal will not be found in other centuries either. My painting proves it."

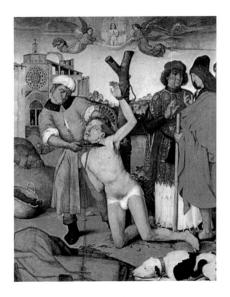

Ayne Bru (Lucius de Brun)

Martyrdom of Saint Cucuphas, c. 1502-7

Oil on panel, 164 x 133 cm (64½ x 52¼ in.)

Barcelona. Museu Nacional d'Art de Catalunya

Dali, Nude, Entranced in the Contemplation of Five Regular Bodies Metamorphosed in Corpuscles, in which Suddenly Appears Leonardo's "Leda", Chromosomatised by the Face of Gala, c. 1954
Oil on canvas, 61 x 46 cm (24 x 18 in.)
Private collection

Dalí, pondering the newly revealed mysteries of the universe, painted a moment of what he calls "floating space", in which "the figures and objects loom up like strange bodies in space. I visually dematerialized matter; then I spiritualized it in order to be able to create energy." The dog borrowed from Ayne Bru's painting establishes the historical link.

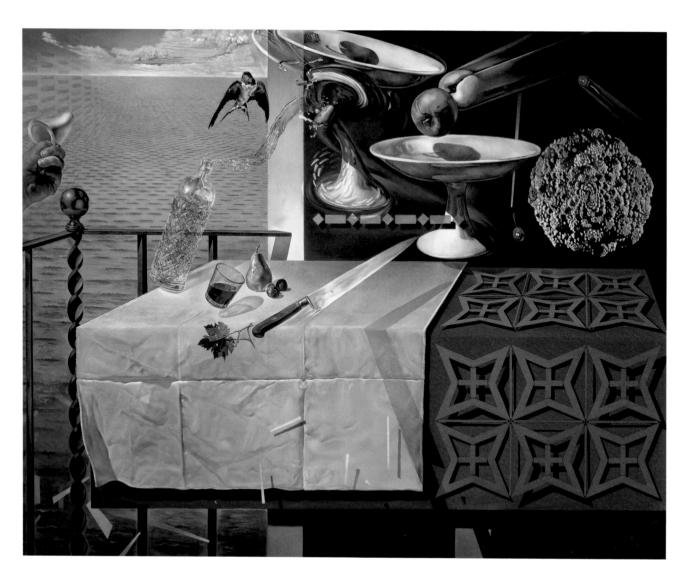

Fast-Moving Still Life, c. 1956 Oil on canvas, 125 x 160 cm (49¼ x 63 in.) St. Petersburg, Florida, The Salvador Dalí Museum

Corpus hipercubus (Based on the treatise on cubic form by Juan de Herrera, builder of the Escorial)/Hypercubic Christ/
Crucifixion, c. 1954
Oil on canvas, 194.4 x 123.9 cm
(76½ x 48¾ in.)
New York, The Metropolitan Museum of Art

Two pictorial solutions to one and the same avowal of mysticism, the logical conclusion of Dalí's Catalan atavism. At the same time they are a synthesis of his past experience. *Corpus hipercubus* is his version of absolute Cubism: "The corpus of the Christ takes the place of the ninth cubus in accordance with the precepts of the discourse on the cubic form by Juan de Herrera, the builder of the Escorial, inspired by Raimundus Lullus."

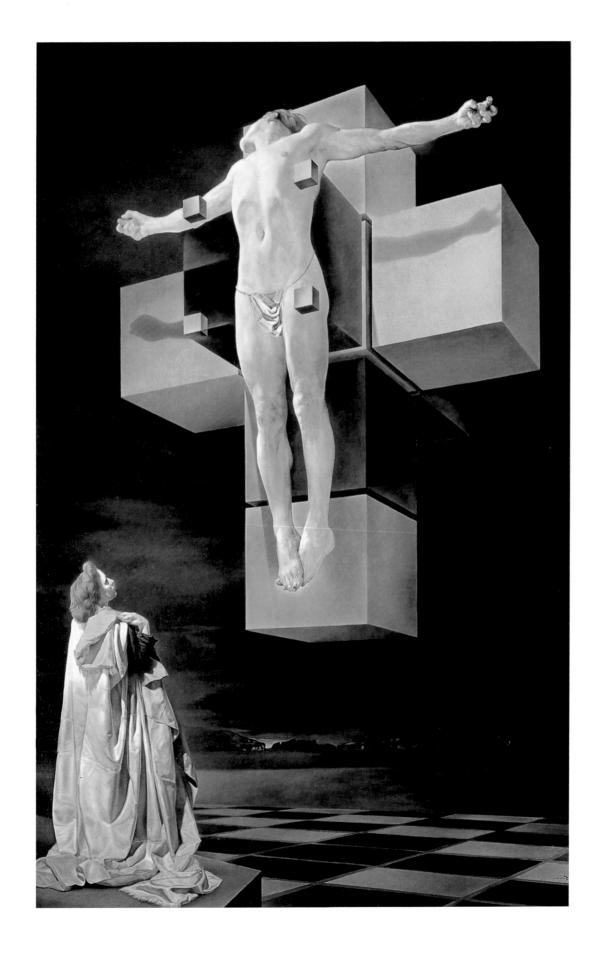

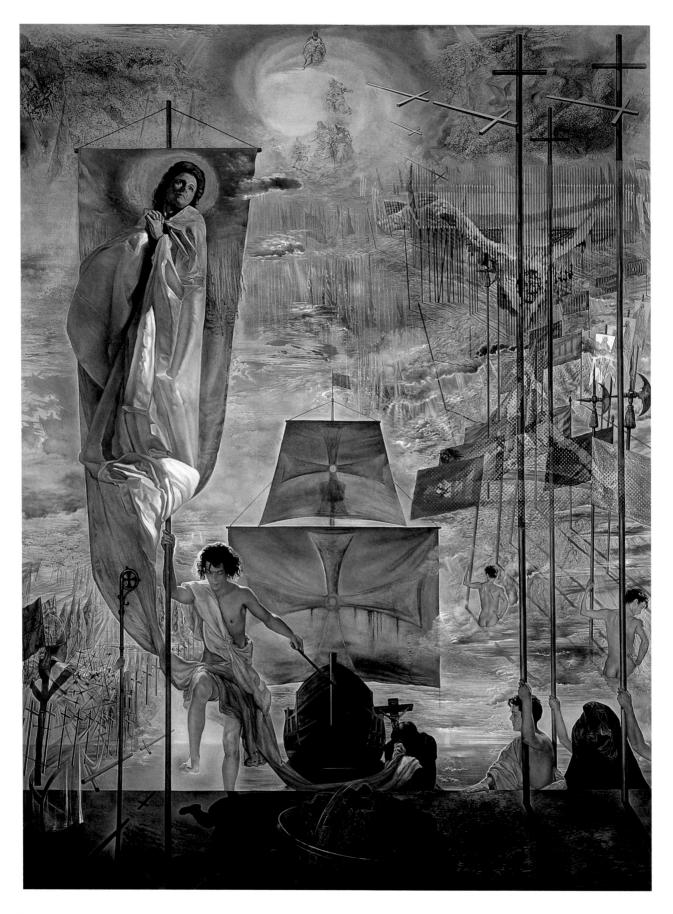

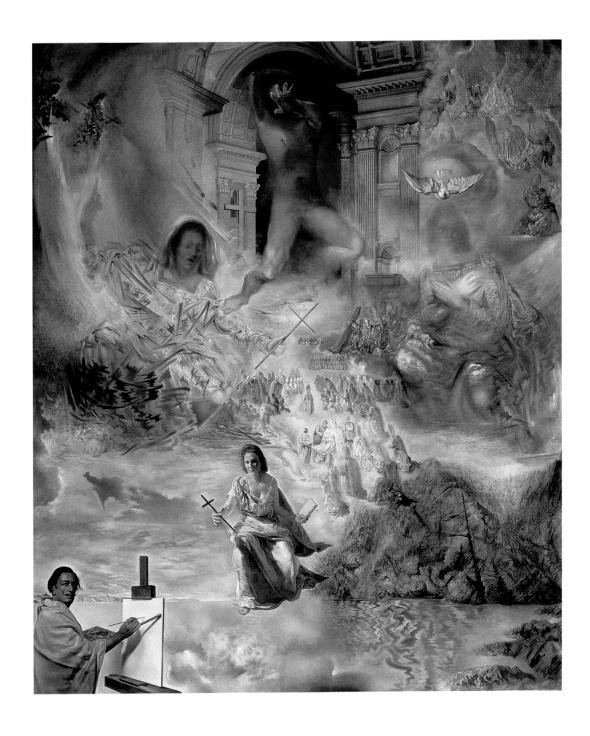

Christopher Columbus/Discovery of America by Christopher Columbus, 1958

Oil on canvas, 410.2 x 310.1 cm (161½ x 122 in.) St. Petersburg, Florida, The Salvador Dalí Museum Oil on canvas, 300 x 254 cm (118 x 100 in.) St. Petersburg, Florida, The Salvador Dalí Museum

The Ecumenical Council, c. 1960

Homages to Velázquez, from whom Dalí borrows, in particular, the splendid halberds carried by the Spanish soldiers in *The Surrender* of Breda. These two paintings are also a sly reference to the "pompiers", academic genre painters such as Meissonier and the Spaniard Maríano Fortuny, whom Dalí had always found "a thousand times more interesting than the representatives of all those fast-fading 'isms' of modem art" and with whom he shared a taste for historical scenes.

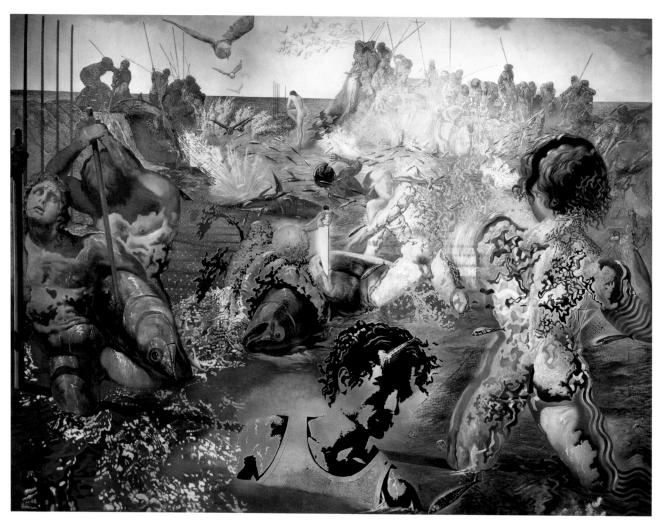

Tuna Fishing, c. 1966–67 Oil on canvas, 304 x 404 cm (119½ x 158¾ in.) Ile de Bendor, Fondation Paul Ricard

Dalí's artistic legacy par excellence, this painting resulted from forty years of passionate experience, synthesizing styles he had already explored: Surrealism, "quintessential pompierism", Pointillism, action painting, Tachisme, geometric abstraction, Pop Art, Op Art and psychedelic art. Subtitled "Homage to Meissonier", it is also a reference to Teilhard de Chardin and his concept of a finite universe and cosmos. This "liberates us from the terrible Pascalian fear that living beings are of no importance compared with the cosmos". Teilhard, on the other hand, "introduced us to the idea that the entire cosmos and universe could meet in a certain point, which, in this case, is *Tuna Fishing*."

The Hallucinogenic Toreador, 1969 Oil on canvas, 398.8 x 299.7 cm (156% x 117% in.) St. Petersburg, Florida, The Salvador Dalí Museum

A double image: the repeated figure of Venus de Milo and its shadows form the features of a toreador. His luminous costume is derived from the multicoloured corpuscles and flies, amidst which a bull impaled with spears can also be seen.

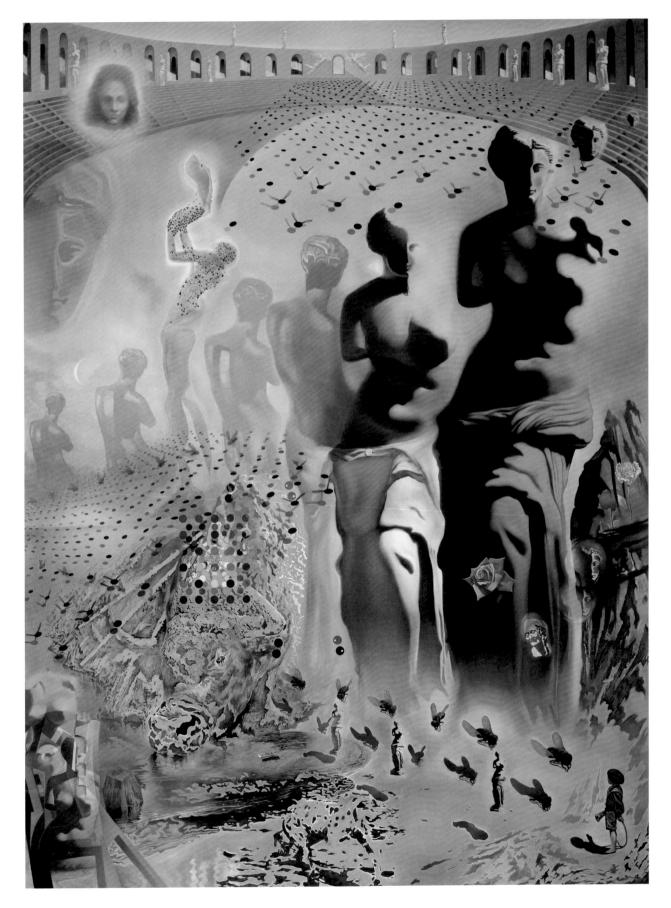

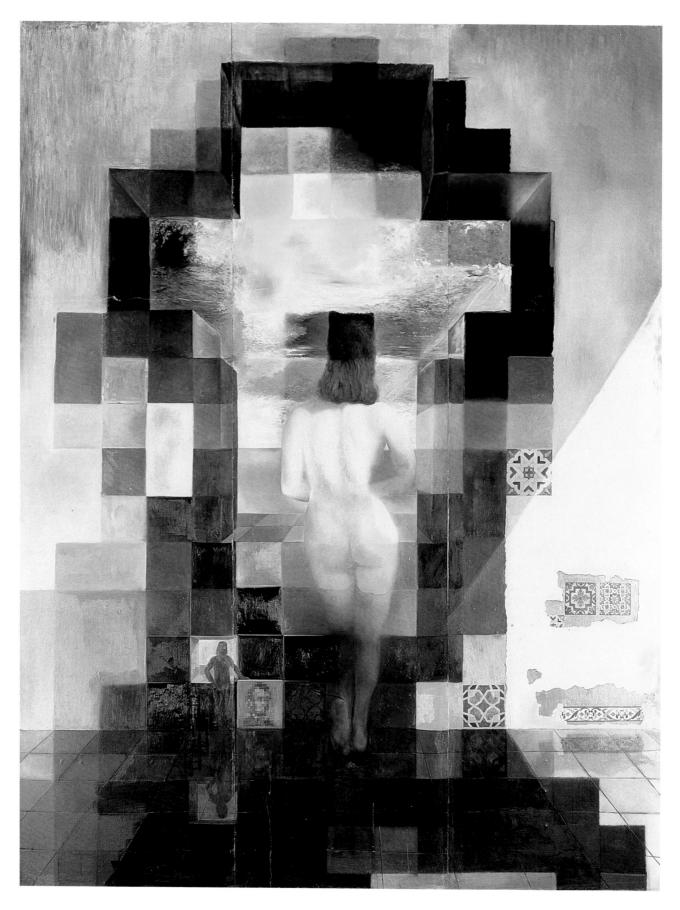

PAGE 88

Gala Nude Looking at the Sea which at 18 Metres Appears the President Lincoln, 1975 Oil on photographic paper on wood, 420 x 318 cm (165¼ x 125¼ in.)
Figueras, Fundación Gala-Salvador Dalí

Gala's naked back evokes the face of Lincoln. The picture is Dalí's version of a digitalized image of Lincoln's face by the American cybernetics specialist Leon D. Hannon.

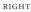

Dalí Lifting the Skin of the Mediterranean Sea to Show Gala the Birth of Venus, 1977 Oil on canvas; stereoscopic work in two sections, 101 x 101 cm (39¾ x 39¾ in.) (right section)

Figueras, Fundación Gala-Salvador Dalí

A further example of binocular vision employing two complementary pictures, a "royal road of the spirit and the metaphysical dimension *par excellence*, for at long last we have recovered the third dimension."

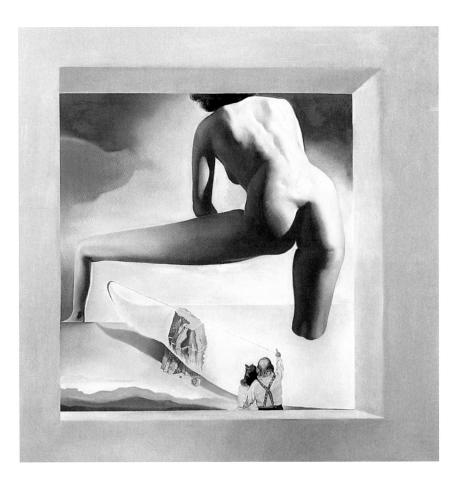

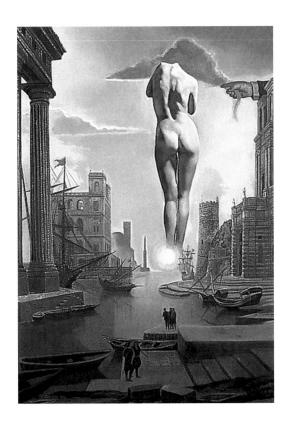

LEFT

Dalí's Hand Drawing Back the Golden Fleece in the Form of a Cloud to Show Gala the Dawn, Completely Nude, Very, Very Far Away Behind the Sun, 1977

Oil on canvas; stereoscopic work in two sections, 60 x 60 cm (23½ x 23½ in.) (right section)

Figueras, Fundación Gala-Salvador Dalí

"Metaphysical photorealism", or an image in relief. Adopting the classic method of stereoscopy, Dalí painted two complementary canvases for this homage to Claude Lorrain, i.e. one for each eye.

The Railway Station at Perpignan, 1965 Oil on canvas, 295 x 406 cm (116 x 159½ in.) Cologne, Museum Ludwig

For Dalí, Perpignan railway station was the centre of the universe. "It is always at Perpignan station ... that I have my most unique ideas. Even a few miles before this, at Boulou, my brain starts moving; but it is the arrival at Perpignan station that marks an absolute mental ejaculation which then reaches its greatest and most sublime speculative height."

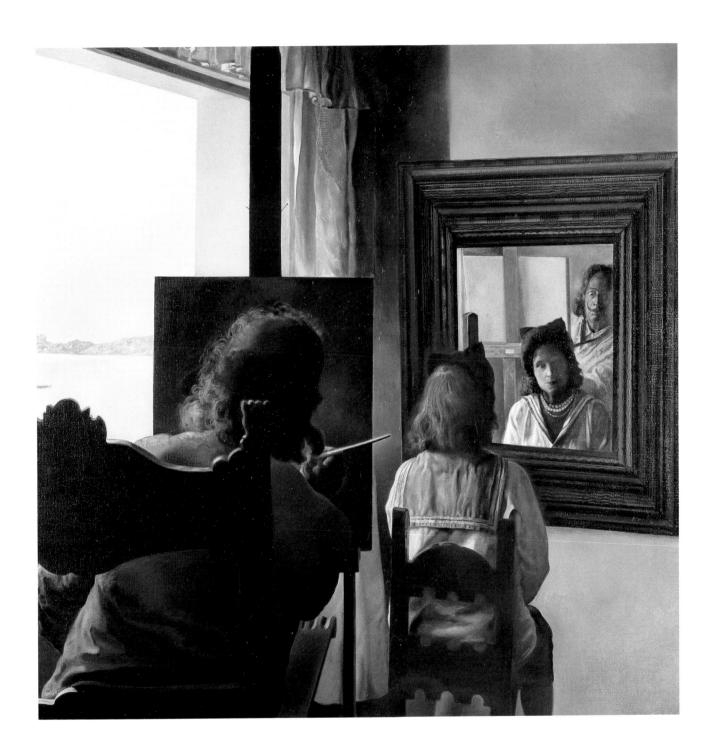

Dalí from the Back, Painting Gala from the Back, Eternalized by Six Virtual Corneas Provisionally Reflected in Six Real Mirrors (unfinished), 1972–73

Oil on canvas; stereoscopic work in two sections, 60 x 60 cm $(23\frac{1}{2} \text{ x } 23\frac{1}{2} \text{ in.})$ (right section) Figueras, Fundación Gala-Salvador Dalí

Yet another stereoscopic painting after the Fresnel grid method that is used for relief

postcards. It was only with the help of the reflecting Wheatstone stereoscope adapted by Roger de Montebello that Dalí succeeded in painting these larger-scale pictures. "Stereoscopy immortalizes and legitimizes geometry, for thanks to it we have the third dimension of the sphere, which is capable of containing and limiting the universe in an august, immortal, incorruptible and royal fashion."

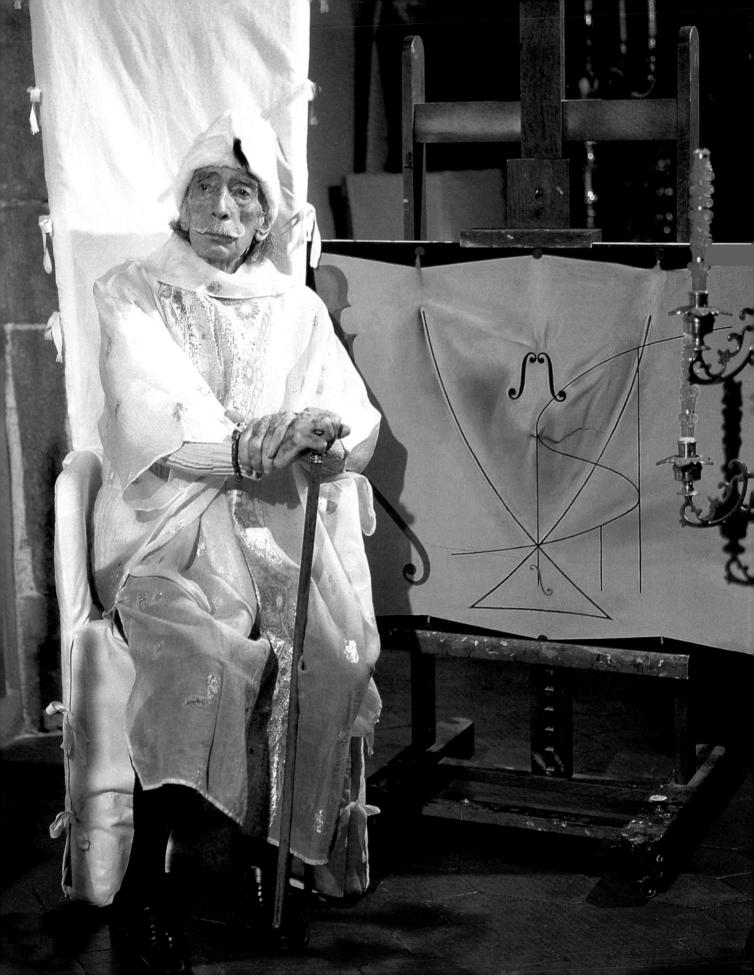

Salvador Dalí 1904–1989 Life and Work

1904 Salvador Dalí is born 11 May at Figueras, Spain. His talent for drawing is apparent from a very early age.

1918 An exhibition of his work at the theatre in Figueras attracts the attention of the critics.

1919 He publishes articles on the old masters in a local magazine, and *Quand les bruits s'endorment* (poems).

1921 Dalí's mother dies in February. In October Dalí is accepted at the San Fernando Academy of Art in Madrid. He lives in a student residence, where he makes friends with Federico García Lorca and Luis Buñuel.

1923 Dalí criticizes his lecturers, is responsible for disturbing the peace at the Academy, and is subsequently expelled for one year. He is also detained under arrest in Gerona for 35 days, for political reasons.

1925 Dalí spends his holidays at Cadaqués with Lorca. In November he has his first solo exhibition at the Dalmau gallery in Barcelona.

1926 Dalí goes to Paris for the first time and meets Picasso (April). In October he is

permanently debarred from the Madrid Academy.

1927 Military service from February to October. Publishes *Saint Sebastian* and develops an aesthetic theory of objectivity.

1928 Writes *The Yellow Manifesto* with Lluís Montañyá and Sebastià Gasch.

1929 Buñuel and Dalí make *Un Chien Andalou*. The film marks their official acceptance into the ranks of the Paris Surrealists. In the spring, Dalí is in Paris for filming and, through Mira, meets Tristan Tzara, the Surrealists and Paul

Dalí's father, c. 1904

Dalí in Guëll Park, Barcelona, 1908

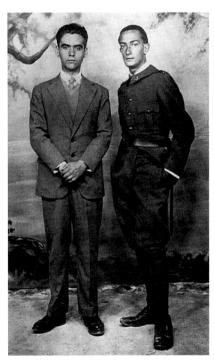

Dalí and García Lorca, Figueras, 1927

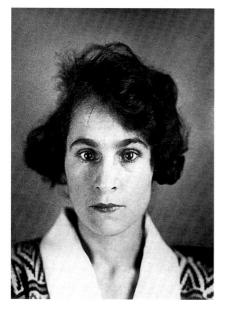

Eluard. In the summer, in Cadaqués, he seduces Eluard's wife Gala. This leads to a break with his father.

1930 He begins to evolve his paranoiac-critical method. In *Le Surréalisme au service de la révolution* he publishes "L'âne pourri", and his *La femme visible* in the "Editions surréalistes". Dalí buys a fisherman's cottage at Portlligat near Cadaqués, and henceforth spends a good deal of each year there with Gala. Right-wing extremists wreck the cinema where the Buñuel/ Dalí film *L'age d'or* is showing.

1931 *Love and Memory* is published in the "Editions surréalistes" series.

1932 Dalí exhibits in the first Surrealist show in the USA. He writes *Babaouo*, a screenplay – though the film, like all his subsequent film projects, remains unmade. The "Zodiaque" group of collectors is established, and regularly buys his work.

1933 In *Minotaure* magazine he publishes his article on edible beauty and Art Nouveau architecture, which revives interest in the aesthetics of the turn of the century.

1934 He exhibits *The Enigma of William Tell*. This leads to arguments with the Surrealists and André Breton. Dalí's New York exhibition is a triumphant success.

1936 The Spanish Civil War begins. Lecturing at a Surrealist exhibition in London, Dalí narrowly escapes suffocating in a diving suit. In December he makes the cover of *Time* magazine.

1937 Dalí writes a screenplay for the Marx Brothers and meets Harpo Marx in Hollywood. In July he both paints and writes *The Metamor*- phosis of Narcissus, a wholesale exercise in the paranoiac-critical method. He designs for Elsa Schiaparelli. Breton and the Surrealists condemn his comments on Hitler.

1938 Dalí exhibits in the Surrealist exhibition in Paris (January). He visits Freud in London (July) and draws a number of portraits of him.

1939 The breach with the Surrealists is now final. André Breton anagramatically dubs Dalí "Avida Dollars". In the United States Dalí publishes his pamphlet *Declaration of the Independence of the Imagination and the Rights of Man to His Own Madness*. In November *Bacchanale*, a ballet, is premièred at the Metropolitan Opera in New York, with libretto and set design by Dalí and choreography by Léonide Massine.

1940 After briefly visiting Paris, Dalí and Gala return to New York, where they remain in exile until 1948.

1941 Dalí-Miro exhibition in The Museum of Modern Art, New York.

1942 The Secret Life of Salvador Dalí is published in America.

1946 Dalí sketches cartoons for Walt Disney, and designs sequences for Alfred Hitchcock's film *Spellbound*.

1948 50 *Secrets of Magic Craftsmanship* is published in America.

1949 Dalí and Gala return to Europe. Dalí designs productions by Peter Brook (*Salomé*)

PAGE 92 Dalí in front of his last painting at the castle at Pubol, 1983 Photo by an unknown author

PAGE 94:
TOP LEFT
Gala, c. 1930 (photo by Man Ray)
TOP RIGHT
The Surrealist group in Paris, c. 1930.
From left: Tristan Tzara, Paul Eluard, André
Breton, Hans Arp, Salvador Dalí, Yves Tanguy,
Max Ernst, René Crevel, Man Ray (photo by
Man Ray)
BOTTOM LEFT
Cover of Time magazine, 14 December 1936
BOTTOM RIGHT
Cover of Diary of a Genius, 1964

RIGHT

Dalí presents Franco with the equestrian portrait of his granddaughter, 1974

and Luchino Visconti (*As You Like It*). He paints *The Madonna of Portlligat*.

1951 Dalí publishes *The Mystical Manifesto*. Beginning of his particle period.

1952 Exhibits in Rome and Venice. Nuclear mysticism.

1953 Triumphant lecture on the phenomenological aspects of the paranoiac-critical method at the Sorbonne (December).

1954 Filming begins on *L'Histoire prodigieuse de la Dentellière et du Rhinocéros*, directed by Robert Descharnes.

1956 Exhibits at the National Gallery, Washington (DC).

1958 12 May: Dalí presents a fifteen-metre loaf of bread at a happening at the Théâtre de l'Etoile, Paris.

1959 Dalí presents the "ovocipede" he has invented in Paris.

1960 Dalí paints large-format mystical works such as *The Ecumenical Council*.

1961 The Ballet of Gala is premièred in Venice, with libretto and set design by Dalí and choreography by Maurice Béjart. Dalí gives a lecture on the myth of Castor and Pollux at the Paris Polytechnic.

1962 Publication of *Dalí de Gala* by Robert Descharnes.

1963 Dalí publishes *The Tragic Myth of Millet's* "*Angelus*". He begins to see Perpignan railway station as the centre of the universe.

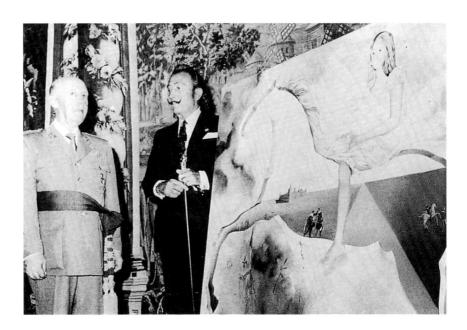

1964 First major Dalí retrospective in the Seibu Museum, Tokyo. Dalí publishes the *Diary of a Genius*.

1971 The Salvador Dalí Museum is opened in Cleveland, Ohio, with the E. and A. Reynolds Morse Collection, which will subsequently be transferred to Saint Petersburg, Florida, in 1982.

1978 Dalí discovers René Thom's work on mathematical catastrophe theory. April: Exhibits his hyperstereoscopic paintings at the Solomon R. Guggenheim Museum. May: Becomes a member of the Académie des Beaux-Arts, Paris

1979 The Centre Georges Pompidou (Paris) shows a large Dalí retrospective which travels to the Tate Gallery in London.

1982 10 June: Death of Gala. July: Dalí is created Marquis de Pubol. From now on he lives in the castle at Pubol which he had given to Gala.

1983 Creation of the perfume "Dalí". An important retrospective is seen in Madrid and Barcelona. May: Dalí paints his last picture, *The Swallow's Tail*.

1984 Dalí is severely burnt in a fire in his room at Pubol. Robert Descharnes publishes *Salvador Dalí. The Work, The Man* (New York, 1984). Retrospective in the Palazzo dei Diamanti, Ferrara (Italy).

1989 23 January: Dalí dies of heart failure in the Torre Galatea, where he has been living since the fire in Pubol Castle. He is interred in the crypt of his Teatro-Museo in Figueras as he himself wished. In his will he leaves his entire fortune and works to the Spanish state. In May a large retrospective is seen in Stuttgart, subsequently in Zurich.

1990 The Montreal Museum of Fine Arts shows an exhibition of over one hundred Dalí works. The Dalí estate is willed to the state of Spain, with the works to be divided between Madrid and Figueras. Fifty-six paintings will be housed in the Teatro Museo Dalí, Figueras, Spain, and possibly also in Barcelona, and 130 paintings will be exhibited in Catalonia.

Photo credits

The publishers wish to thank Descharnes & Descharnes and the following institutions:

akg-images, Berlin: p. 74 Courtesy of the Salvador Dalí Museum, St. Petersburg, Florida: pp. 13, 15, 30, 77 (top), 85. Glasgow City Council (Museums): p. 76. Rheinisches Bildarchiv, Cologne: p. 90. Süddeutscher Verlag Bilderdienst, Munich: p. 95.

© Tate, London: pp. 52-53.

© Time magazine: p. 94 bottom left

The illustrations on the following pages are taken from the archives of the author: pp. 74, 77 (bottom), 78 (top).

Imprint

EACH AND EVERY TASCHEN BOOK PLANTS A SEED!

TASCHEN is a carbon neutral publisher. Each year, we offset our annual carbon emissions with carbon credits at the Instituto Terra, a reforestation program in Minas Gerais, Brazil, founded by Lélia and Sebastião Salgado. To find out more about this ecological partnership, please check: www.taschen.com/zerocarbon Inspiration: unlimited. Carbon footprint: zero.

To stay informed about TASCHEN and our upcoming titles, please subscribe to our free magazine at www.taschen.com/magazine, download our magazine app for iPad, follow us on Twitter, Instagram and Facebook, or e-mail your questions to contact@taschen.com.

© 2017 TASCHEN GmbH Hohenzollernring 53, D-50672 Köln www.taschen.com

Original edition:

© 1994 Benedikt Taschen Verlag GmbH
© Salvador Dalí. Fundació Gala–Salvador Dalí/
VG Bild-Kunst, Bonn 2015, for the works of Dalí
© for the U.S.: Salvador Dalí Museum, Inc.,
St. Petersburg, Florida, for the illustrations on pages 13, 15, 30 and 85
© Man Ray Trust/VG Bild-Kunst, Bonn 2015, for the works of Man Ray
Conception: Gilles Néret, Paris
English translation: Catherine Plant, Berlin
Design: Birgit Eichwede, Cologne
Production: Tina Ciborowius, Cologne

Printed in Slovakia ISBN 978-3-8365-6000-9 PAGE 2 Salvador Dai

Salvador Dalí photographed in 1971 by Descharnes in front of the statue of Ernest Meissonier by Antonin Mercié (1895)

PAGE 4

One Second Before the Awakening from a Dream Provoked by the Flight of a Bee around a Pomegranate/Dream Caused by the Flight of a Bee around a Pomegranate, One Second before Awakening, c. 1944 Oil on wood panel, 51 x 41 cm (20 x 16 in.) Madrid, Museo Thyssen-Bornemisza